ETCHING

ETCHING

LEONARD EDMONDSON

VNR VAN NOSTRAND REINHOLD COMPANY

New York Cincinnati London Toronto Melbourne

I dedicate this book to Grace

Acknowledgments

The author wishes to thank Mr. Fenton Kastner, Curator
of Prints, Achenbach Foundation for Graphic Arts, Califor-
nia Palace of the Legion of Honor, San Francisco; Dr. E.
Maurice Bloch, Curator, and Katherine A. Smith, Assistant
to the Curator, Grunwald Graphic Arts Foundation, Univer-
sity of California, Los Angeles; Mr. Gerald Nordland,
Director, Sue Foley, Curator of Prints, and Ellen Ditzler,
Curatorial Assistant, San Francisco Museum of Art; Dr.
Peter Selz, Director, Joy Feinberg, Registrar, and Mya Pel-
letier, Assistant to the Registrar, University Art Museum,
University of California, Berkeley; Mr. Joseph E. Young,
Curator of Prints, Los Angeles County Museum of Art.

John Uomoto, photographer and designer, who took
all of the technical photographs and made suggestions
for the layout and the jacket design for the book.

Shiro Ikegawa, Corwin Clairmont, and Gordon Thorpe
for their help in staging the technical demonstrations.

Van Nostrand Reinhold Company Regional Offices:
New York Cincinnati Chicago Millbrae Dallas
Van Nostrand Reinhold Company International Offices:
London Toronto Melbourne

Library of Congress Catalog Number 72-2662
ISBN 0-442-22235-1

Printed in England by Jolly and Barber Ltd. Rugby, Warwicks.

Published in 1973 by Van Nostrand Reinhold Company
A Division of Litton Educational Publishing, Inc.
450 West 33rd Street, New York, N.Y. 10001
and Van Nostrand Reinhold Company Ltd.
25-28 Buckingham Gate, London SW1 E6LQ
Published simultaneously in Canada by
Van Nostrand Reinhold Ltd.

16 15 14 13 12 11 10 9 8 7 6 5 4 3 2 1

Contents

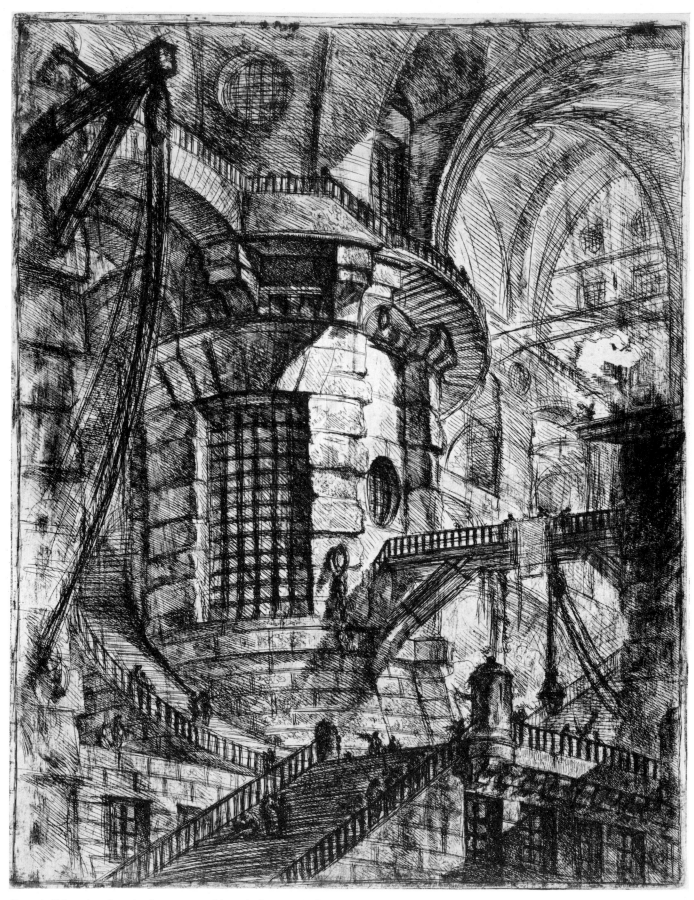

Carceri (Prisons), plate 3, first-state etching, before 1760, by Giovanni Piranesi (California Palace of the Legion of Honor, gift of Osgood Hooker)

Introduction

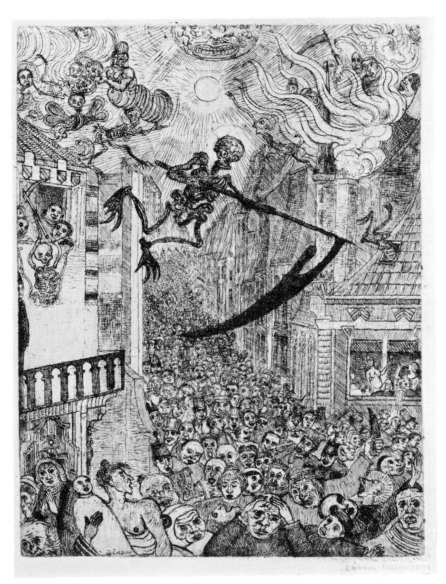

Death Pursuing the Herd of Humanity, etching, 1896, by James Ensor (Achenbach Foundation for Graphic Arts, California Palace of the Legion of Honor)

The etcher is a rare combination of artist, craftsman and chemist. He uses an indirect method of transferring an image from one surface to another to accomplish vigorous, straightforward results, and he performs his craft skillfully with techniques, processes, and recipes that are sometimes highly complex.

An etching is distinguished from all other prints —woodcut, silk-screen, lithograph—by the unique way it is inked and printed. The plate is inked so that the scratches and valleys are filled with ink, and then the surface of the plate is wiped clean with a rag. The plate and paper are run through the etching press under considerable pressure, exerted through felt blankets. This forces the paper into the scratches and valleys in the metal plate, thus transferring the ink from the plate to the paper. Printing methods are substantially the same for all etchings, and the process has not changed considerably since the first etching press was used.

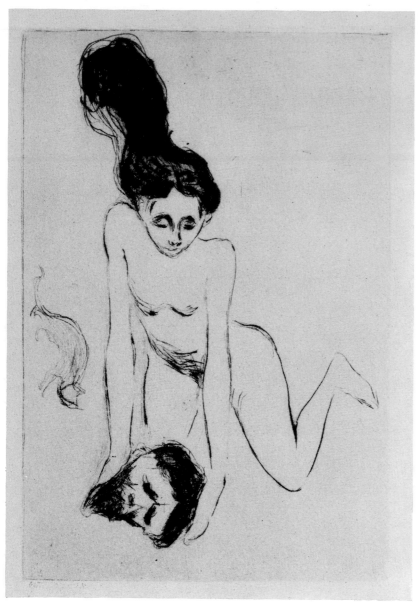

The Cat, etching by Edvard Munch (Achenbach Foundation for Graphic Arts, California Palace of the Legion of Honor)

The unique etching process is called *intaglio* printing, and it is particular to the etcher's art. When the paper is removed from the plate, the characteristic qualities of the intaglio print are evident: (1) the print has a distinct *plate mark*—that is, an impression of the perimeter of the plate, and (2) the printed portions are *embossed*—that is, the scratches and valleys in the plate become ridges and bumps on the paper.

Each etching is considered to be one of an edition of multiple-originals. In the etching tradition, the artist both conceives and executes the print himself. When others help him in the technical execution of the plate and the printing, he supervises the procedure at every stage.

In recent times, stimulated by a public exposed to increased use of color in books, cinema, and television, etchers have produced prints of a generally larger size and with bolder colors than are traditional in the medium. Some of the finest artists in the United States make prints occasionally, or frequently, because they are stimulated by the indirect technique, attracted to the idea of multiple-originals, or interested in collaborating with an artisan printer. Compared to the mountains of words and pictures piled up by the mass media, the printmaker's signed and numbered limited edition is like a few grains of sand. Yet, because the original print reflects each artist's concern with and response to his time and his environment, it

is a human expression at its purest and most intense, and it endures far beyond the moment. The etching medium, because of its versatility, promises continued innovation and vitality.

In addition to photographs of selected examples of the etcher's art and craft, this book includes a detailed account of materials, techniques, and processes used in etching, some of which vary a great deal from the traditional intaglio printing. These techniques show that new materials and new processes have caused a gradual breakdown of the boundaries between media, which has led to a re-evaluation of printmaking. Each etcher will adjust and modify the technical guidelines given here to reflect his individual personality and meet his own expressive needs.

This book is based on my knowledge and experience as an etcher, gained through more than twenty years of intense activity in the field. Writing it affords me the opportunity to honor some of the etchers who are shaping the present and influencing the future of printmaking, and to offer my opinions about etching. Although the technical information is directed primarily to etching students, I believe that, because of its broad range, this book will be of equal interest to all printmakers and print collectors, no matter where their special interests lie.

Self Portrait, etching by Marc Chagall (Achenbach Foundation for Graphic Arts, California Palace of the Legion of Honor)

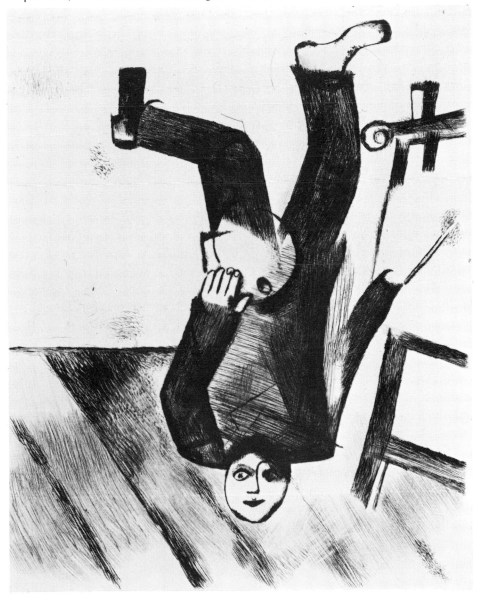

TRADITIONAL TECHNIQUES IN ETCHING

Time-tested and time-honored materials and processes in etching have been used not only by etchers of the past whose work is of cultural and artistic merit, but also by significant contemporary etchers who continue to work in the traditional manner.

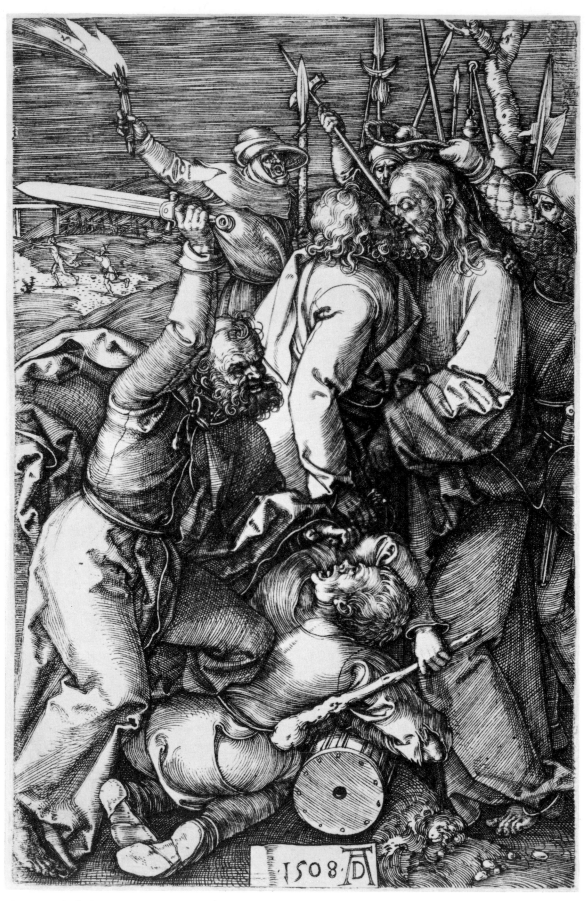

The Betrayal of Christ, engraving, 5 x 5 inches, 1508, by Albrecht
Durer (Achenbach Foundation for Graphic Arts, California Palace
of the Legion of Honor)

1. Line, Tone and Texture

Line

Line is essential to traditional etching, and the etcher may choose to work with engraved line, drypoint line, or etched line as methods to draw on the metal plate; or he may combine all three techniques in one etching. There are two distinctly different methods of making an etching: with or without the use of acid. The engraved line and the drypoint line are incised directly by hand into the metal, using a metal tool. The etched line is incised by acid, or *mordant*, after the etching needle has penetrated the *hard ground*—an acid-resistant covering—and exposed the metal. Drypoint is a method of drawing directly on metal with a tool that raises a metal burr; characteristically this line prints dark and furry. Engraving is a method of drawing directly on a metal plate with a tool that removes a ribbon of metal; characteristically this line prints sharp and crisp. Because of its fluidity and variety, the line etched with acid is the most popular. The engraving technique is too arduous; the drypoint method too fragile.

The first intaglio plates made by the etcher were engraved line drawings made with a *burin* and without the use of acid. The burin, the same tool originally used by the artisan who decorated armor plate, is designed to incise directly into the plate, lifting a ribbon of metal and leaving a channel that holds the ink. When the plate is printed, the ink is transferred from the plate to the paper to make an intaglio print. Burins come in several different sizes, with a variety of cutting points. It is important to keep the point of the burin sharp in order to cut cleanly and to avoid slipping.

Copper has long been the favorite metal for the engraving plate. It is softer than iron or steel and not as brittle as zinc or aluminum. In copper, the engraver can cut long, unbroken grooves. He holds the burin with the wooden handle resting in the palm of his hand and his index finger guiding the blade. The blade is pushed directly away from the body with one hand, while the other hand turns the plate when a change of direction is required. Ordinarily the blade is held at a very low angle, almost parallel to the plate. The degree of angle influences the depth of the line. A low angle produces a shallow line. A steep angle yields a deeper line. Incising lines on a copper plate with a burin is a laborious, painstaking exercise; to become skillful with the burin requires practice.

The engraver may improvise directly on the copper or may transfer a drawing to the metal with pencil, chalk, or carbon paper before cutting. The drawing made with the burin is somewhat formal, and the line is typically hard and sharp. Wide, deep lines can be made by gouging the same line several times with a small burin or by using a larger burin. Tonal effects of light and shadow can be created by cutting parallel or crosshatched lines; textural effects, by using the engraving tool to make dots or other marks. Often the formal quality of the engraved line is used in connection with the fluid quality of the etched line to provide an interesting visual contrast.

Engraving with a burin

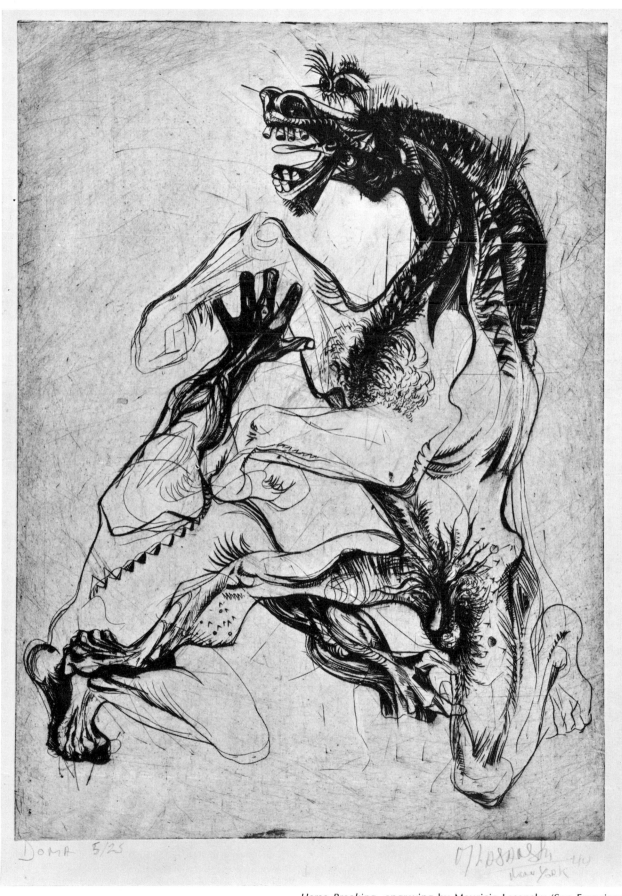

Horse Breaking, engraving by Mauricio Lasansky (San Francisco Museum of Art)

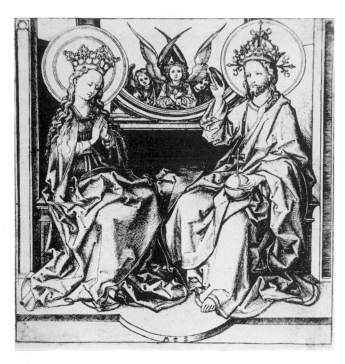

Christ Blessing the Virgin, engraving by Martin Schongauer (Grunwald Graphic Arts Foundation, University of California, Los Angeles)

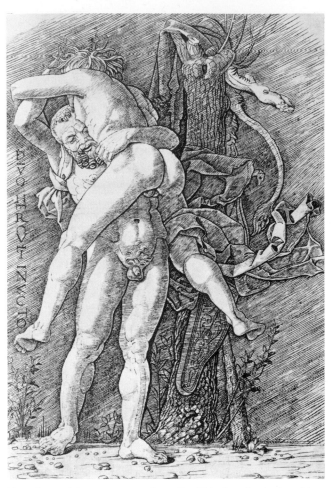

Hercules and Antaeus, engraving, 16 x 17 inches, by Andrea Mantegna (Achenbach Foundation for Graphic Arts, California Palace of the Legion of Honor)

Marriage a la Mode, engraving by William Hogarth (Collection of California State College at Los Angeles)

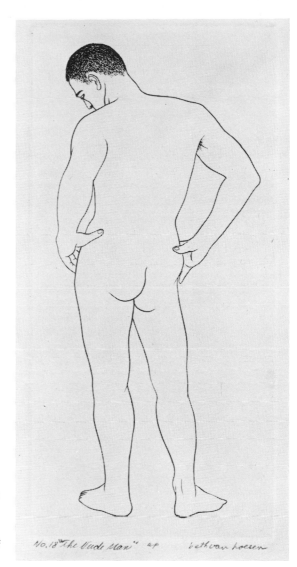

The Nude Man, intaglio engraving, 8½ x 4 inches, by Beth Van Hoesen

Locust, engraving by Walter Rogalski (San Francisco Museum of Art)

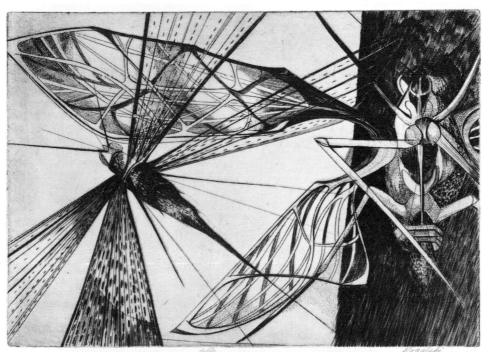

Drypoint is the result of another traditional drawing technique to produce line that does not require acid. The etcher scratches lines directly into the copper or zinc plate with a sturdy, sharp-pointed tool. There are many different ready-made drypoint tools available in etchers' supply stores, or an etcher can make his own by grinding a dental tool to a sharp point.

The drypoint needle does not remove metal as the burin does, but instead raises a *burr,* a furrow of metal on one or both sides of the line, which primarily holds the ink. In order to raise a burr, the engraver must hold the needle at a low angle to the plate, jab it into the metal, and pull it firmly toward himself. The result is a deep scratch in the metal. The line prints dark, blurry, and wide but it can also print a rich dark area of tone, made by scratching a pattern of parallel or crosshatched lines.

Drypoint is perhaps the simplest and quickest method of drawing on a plate, and the drawings often have vitality and spontaneity. However it is not very frequently used alone, because of the fragility of the burr. This makes the plate difficult to wipe, and severely limits the number of good copies that can be printed. Many etchers have used the drypoint method exclusively to make a drawing on the plate, but it has been most commonly used to support etched-line drawings.

Drawing with a drypoint tool

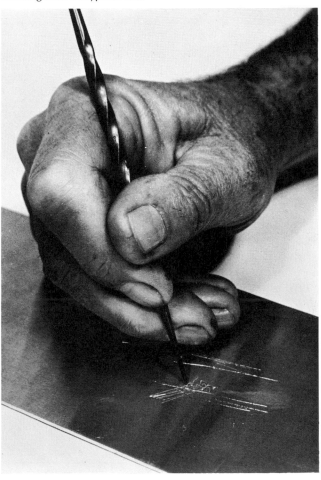

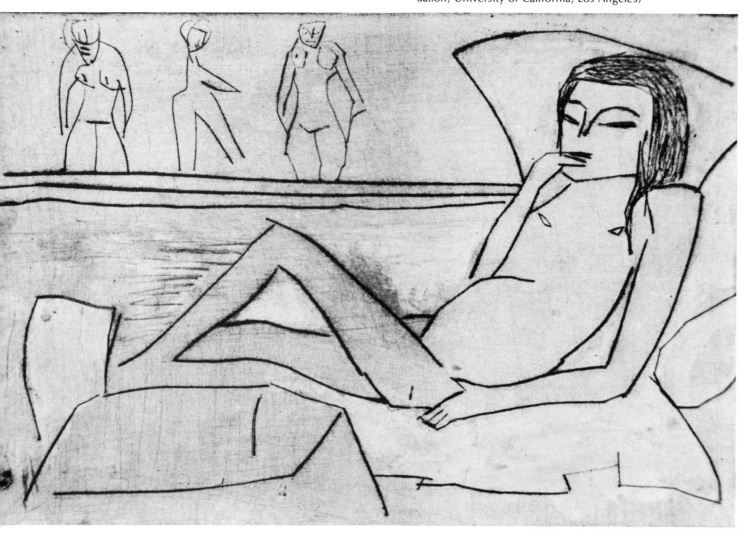

Nude, drypoint by Erich Heckel (Grunwald Graphic Arts Foundation, University of California, Los Angeles)

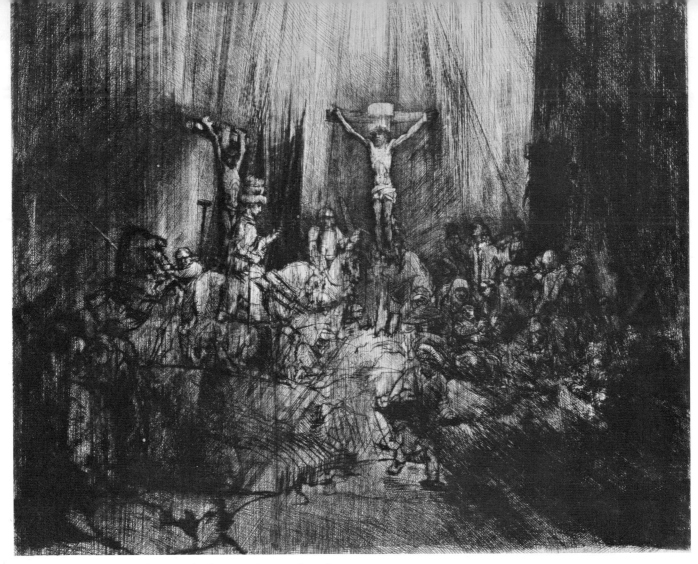

The Three Crosses, etching and drypoint by Rembrandt
(Achenbach Foundation for Graphic Arts, California Palace of the
Legion of Honor)

Job, drypoint by Georges Braque (Achenbach Foundation for
Graphic Arts, California Palace of the Legion of Honor)

Still Life, drypoint by Francis Picabia (San Francisco Museum of
Art)

Eden Revisited, drypoint, 22 x 28 inches, by Louis Lunetta

L'Effort, etching with drypoint, 1939, by Jacques Villon (Achenbach Foundation for Graphic Arts, California Palace of the Legion of Honor)

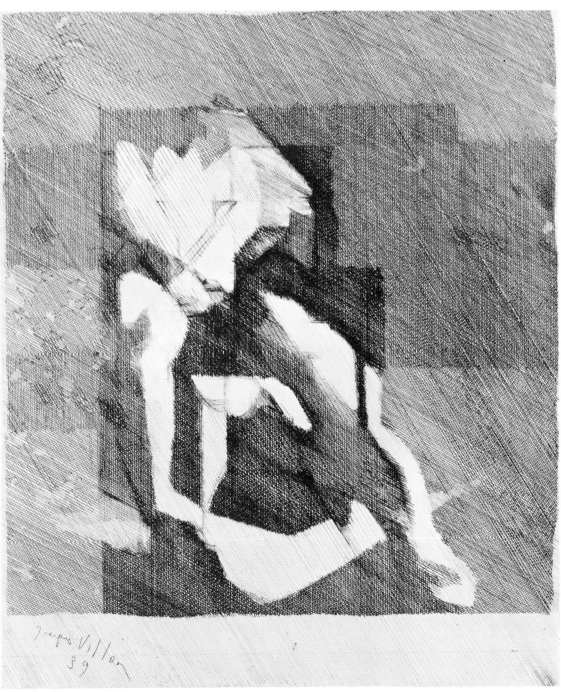

To make an *etched-line* drawing, the etcher uses an etcher's needle and acid. First he covers a copper or zinc plate with a thin coat of hard ground, which protects the plate and, at the same time, is thin enough and yielding enough to be penetrated by the needle, thus exposing the metal to the acid. Hard ground comes in two forms, *ball ground* and *liquid ground*. While both grounds are equally acid-resistant, the ball ground can often be applied in a thinner, more even coat.

Ball ground, a mixture of beeswax, asphaltum, and rosin, can be bought in an etcher's supply store or prepared in the artist's studio. The recipe calls for equal parts of beeswax and asphaltum and a pinch of rosin powder. The ingredients are melted together in a pan, and the mixture is made into a ball by pouring the required amount into a container of cold water. When the material is cool enough to handle, the balls are formed by hand. Each ball is usually wrapped in a cloth and tied with a string or rubber band, for convenience in handling.

When ready to apply ball ground, the etcher places the plate on a hot plate, and warms it to a temperature sufficient to melt the ball ground. After enough to cover it has melted, he removes the plate from the stove and rolls the still-warm ground with a hard rubber *brayer,* or roller, until the coating is thin and smooth. The etching plate must cool and the ground harden before a drawing can be started. Ball hard ground can be penetrated easily by the etching needle and resists acid in an acid bath for a long time.

The liquid hard ground is made of asphaltum that has been diluted to a brushing consistency with chloroform, benzine, or paint thinner. The commercially prepared liquid hard ground is usually asphaltum diluted with ether or chloroform. Liquid asphaltum may be purchased in a paint store or a hardware store, and when diluted with one of the solvents above, it makes an inexpensive and satisfactory ground. Whichever liquid hard ground is used, it must be dilute enough for pouring or applying with a brush to produce a thin, even coat.

When ready to pour liquid ground, the etcher places the plate in a container in a tipped position. Then he pours the ground liberally over the plate, allowing it to run down until the entire plate surface is covered. Any excess liquid can be returned to the bottle to be used another time. When the liquid ground is brushed on, the etcher should use a large, soft brush to make the coating as even as possible. The etching plate can be warmed slightly on a hot plate to even out irregularities and hasten evaporation. Liquid hard ground produces a thin, smooth, medium-dark brown coat that also can be penetrated easily by the needle-pointed tool and will resist acid.

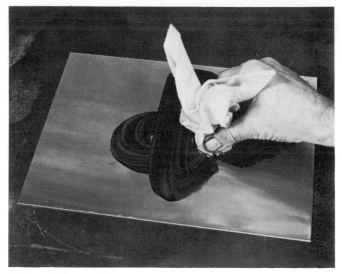

Melting ball ground on a zinc plate

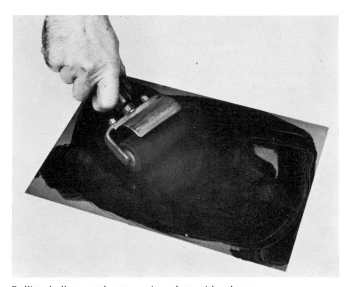

Rolling ball ground onto a zinc plate with a brayer

Painting liquid asphaltum on a zinc plate

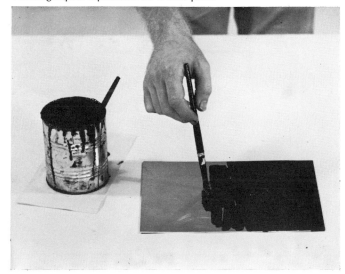

The liquid hard ground must be completely dry before the etcher begins drawing. He can use any sharp-pointed metal tool that satisfies his requirements—etching needle, phonograph needle, darning needle, nail, dental tool, etc. The drawing is made with enough pressure to allow the point of the etching needle to cut through the hard ground and expose the metal. Although no great pressure is required, the etcher must make sure that the needle has exposed the metal so the acid can attack it. The etched line is capable of infinite variations; each artist will use it in a personal way to express himself.

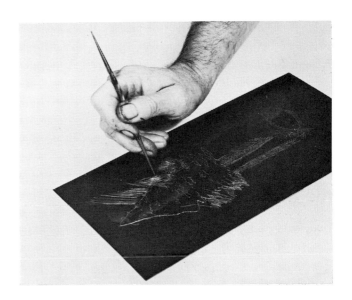

Drawing on hard ground with an etching needle

Night Shadows, etching, 1921, by Edward Hopper (California Palace of the Legion of Honor)

When the needle drawing in hard ground has been completed, the plate is ready to be placed in an acid bath. It is the acid, not the etching needle, that actually incises the lines in the metal plate. Before immersing the plate, the etcher must paint its back and edges with an acid-resistant coat, either liquid asphaltum or stopping-out varnish such as orange shellac. *Stopping out* is covering over areas the etcher does not want exposed to acid. Some plates come from the manufacturer with the back already protected.

Precautions should be taken to use all acids in a well-ventilated room and near a plentiful supply of cold water. In many etching workshops an exhaust fan is placed over the acid trays to remove the toxic fumes. Of course the acid trays must be made of acid-resistant material: glass, plastic, synthetic rubber, etc. Photographic supply dealers are good sources for acid trays, or the etcher can make his own out of plywood—completely coated inside and out—with fiberglass and resin.

There are three *mordants,* or etching solutions, commonly used by the etcher: *nitric acid, hydrochloric acid,* and *ferric chloride.* Nitric acid, the most common mordant for zinc and copper, is prepared for *biting,* or etching, a plate by mixing with water. The proportions that have worked best for me are given in this section, and other mixtures can be found in the literature. For copper, one part (by volume) of acid is added to two parts (by volume) of water; for zinc, one part (by volume) of acid is added to five parts (by volume) of water. Caution! Always add acid to water, rather than water to acid. This ensures a dilute mixture and stops splashing.

The action of nitric acid on metal is signaled by tiny gas bubbles that collect on exposed lines of the plate. For a more even bite, the etcher should remove these gas bubbles from time to time, by tilting the tray or by using a feather. The biting strength of the acid can be estimated by how fast the bubbles form and how vigorously they rise to the surface. Nitric acid eats wide and deep at the same time. It also undercuts the line somewhat. It attacks zinc more forcefully than copper, often biting a rough, ragged line.

Hydrochloric acid is used for etching copper or zinc in a form called *Dutch mordant.* The etcher adds one part (by volume) of hydrochloric acid to nine parts (by volume) of a saturated solution of potassium chlorate in water. With this mordant, there is no bubble action, and the plate must be taken from the acid bath and examined, to determine the speed and depth of the bite. Dutch mordant is a slow, accurate acid that bites straight down and does not undercut. It is particularly useful for fine-line work.

Ferric chloride (iron perchloride) can be used under circumstances where a gentle and controlled action is needed. It is usually bought from the druggist in lump form and dissolved in water. The proportions for an average-strength acid are one part ferric chloride to three parts water. Ferric chloride, like Dutch mordant, eats straight down and does not appreciably widen the line or undercut. Since ferric chloride leaves a deposit of iron in the lines, the plate should be bitten upside down in the acid or should be taken from the acid tray at intervals and washed with water. A 10 per cent solution of hydrochloric acid is said to dissolve the sediment, allowing face-up etching.

Whichever acid he uses, the etcher is free to adjust the strength to suit his technical and artistic needs. Acid bites faster when it is warm and slower when it is cold; faster when large areas are exposed and slower when only a few lines are exposed. How long a plate should remain in acid thus depends on how deep and how wiide the etcher wishes the line to be bitten. After the plate has been bitten to the etcher's satisfaction, he removes it from the acid bath, and immediately rinses it and his hands thoroughly in cold water. Cold water dilutes the acid and stops its action. He then dries the plate with paper towels, removes the hard ground and dissolves the stopping-out varnish on back and sides with paint thinner.

Keep in mind that this is only the first etch. Many etchers do additional drawing on the plate and bite it again. Line variation can be achieved by leaving some lines in the acid a longer time than others. This can be done either by recoating with ground some of the already etched lines and returning the plate to the acid, or by adding further drawing to a plate and putting it back in the acid.

Biting a zinc plate in a nitric-acid bath

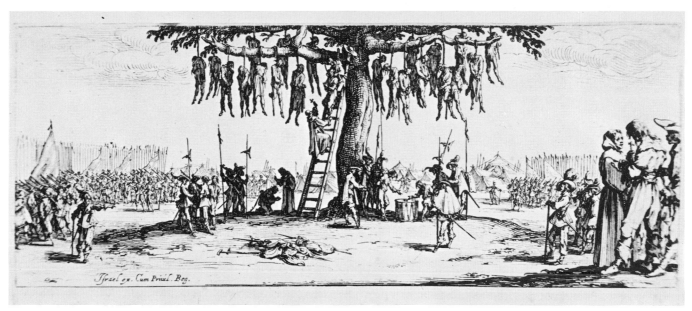

Hanging Tree, etching by Jacques Callot (Grunwald Graphic Arts Foundation, University of California, Los Angeles)

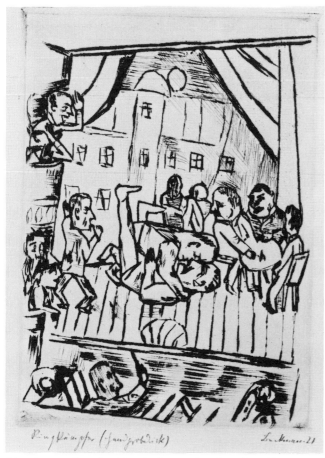

Wrestlers, etching by Max Beckman (San Francisco Museum of Art)

Lunch Counter, etching, 6⅞ x 7¾ inches (plate mark), 1964, by Wayne Thiebaud

Composition, etching by Salvador Dali (San Francisco Museum of Art)

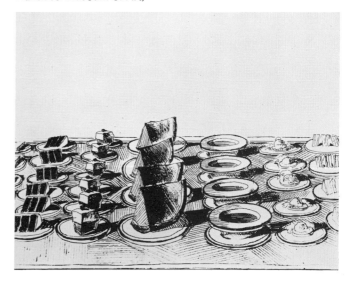

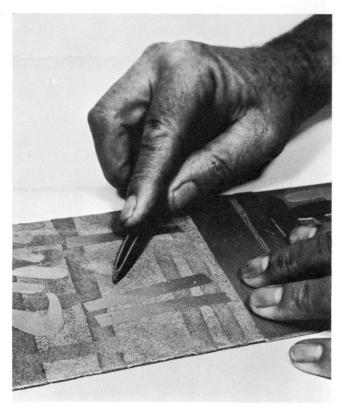

Removing metal from a plate with a scraper

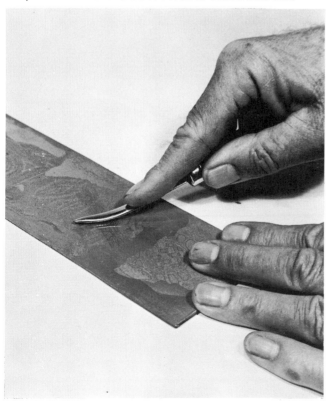

Smoothing the metal surface of a plate with a burnisher. The scraper and burnisher are often used to correct false lines

Additions and Corrections on the Plate

False lines can sometimes be erased from the plate or lines bitten too deeply can be lightened by *scraping* and *burnishing*. A scraper, which is a tool used to remove metal from the plate with both the cutting sides and the tip, is held at a shallow angle and usually drawn toward the user. A burnisher is used to smooth and polish the plate. Both tools must be used with great care since they may leave unwanted marks on the metal plate. A drop or two of oil on the plate prevents the burnisher from scratching it excessively. Fine sandpaper or steel wool is sometimes used to supplement the work of the burnisher.

Soft-ground Line

Although it is less frequently used by etchers today than other line methods, soft-ground line can be effective and interesting. To make a *soft ground,* the etcher coats the plate with a mixture of equal parts of liquid asphaltum and either axle- or wheel-bearing grease or tallow. He applies this paste with a cardboard *scraper* or a brush. The scraper, which can also be used for inking, is merely a conveniently sized piece of cardboard, about 2 inches square. Soft ground never hardens. It is also made commercially, and can be bought in ball or paste form. To apply the ground, the etcher warms the plate slightly, applies enough soft-ground paste to coat the surface, then removes the plate from the heat, and rolls the paste smooth and thin with a soft rubber brayer.

To make the drawing, the etcher first lays a piece of thin paper (tissue or tracing paper) on the coated plate. Then, using the sharp point of a hard lead pencil, he makes (or traces) his drawing on the paper, and, when it is completed, he carefully removes the paper. Wherever the pencil has pressed the paper into the soft ground, the asphaltum is removed, exposing the plate to the acid. Or the etcher can draw directly into the soft ground with a stick or a pencil. Because such marking tools do not scratch the surface of the plate as the etching needle does, the plate can be regrounded and redrawn as many times as necessary, and any false lines stopped out, before the plate is placed in acid. The plate is left in acid until the lines are bitten deep enough and then is rinsed in cold water. The soft ground is removed with paint thinner. Soft-ground line is usually wide, and it is often gray in tone, resembling the line made by a litho pencil or soft lead pencil.

Tribulation, color etching, aquatint, soft-ground, and engraving, by Lee Chesney

White Line and Relief Line

Depending on the kind of inking done on the plate, the line will create either a white drawing on a black field, or a black drawing on a white field. Intaglio inking, which eventually produces the black drawing, is done by first covering the entire plate with etching ink and then wiping away all the ink but that which has been trapped in the scratches and indentations in the plate. Relief inking, which eventually produces the white drawing, is done by rolling a thin coat of ink over the entire surface of the plate. The scratches and indentations escape the ink, and print white, while the top surface prints the black background.

A *white line* drawing can be made by drawing on the bare plate with an acid-resistant material such as liquid asphaltum, litho pencil, or wax crayon. Acid will attack only the areas around the protected lines so that inking intaglio produces a plate that prints white line surrounded by tonal areas. The tonal area will print darker if aquatint (see below, this chapter) is added to the plate after the surface has been bitten down slightly.

Another kind of white line print can be made by inking an ordinary engraved-line or etched-line drawing by the relief method instead of intaglio. The relief-rolled print will have white lines on a black field.

In the relief-line method, the line is drawn with an acid-resistant material on a bare plate. Then the open plate around the line is bitten very deeply, and the plate is inked in relief like a wood block, using stiff ink and a soft rubber brayer.

Tone and Texture

Tonal areas and modeling are sometimes made with closely placed parallel lines or crosshatching. However, the etcher has at his disposal even more effective methods of creating tone. *Aquatint*, the most widely used technique for making tonal areas, creates uniform tones either light or dark in value and coarse or fine in texture.

Aquatint and soft-ground methods are the principal ways to produce tone and texture in areas, as opposed to line drawing. Every etcher should use his initiative and imagination to discover new means to make tonal and textural areas that suit the needs of his art.

To make a *rosin aquatint,* the etcher needs a supply of finely ground *rosin,* a pine-tar resin, which can be bought ready-to-use from the hardware store, artists' supply store, or drug store. Or the etcher can buy lump rosin and grind it into powder by enclosing it in a cloth bag and pounding it with a mallet until the powder is sufficiently fine for the aquatint. Some etchers prefer to grind their own rosin because then they can control the size of the particles of rosin dust. For powdered rosin, the etcher may substitute asphaltum powder, which is darker brown in colour and makes a somewhat darker aquatint.

To free the plate of dirt and grease before dusting on the rosin powder, the etcher can wash it in warm water with liquid detergent. After it is thoroughly dry, he dusts a coat of rosin powder over the surface of the plate where the aquatint tone is needed. The dusting can be done by using a cloth bag filled with rosin, finely woven or coarsely woven depending on the size of the particles desired, a fine-meshed sieve, or a specially made aquatint box. The cloth bag and the sieve act as strainers, allowing the finer dust to fall through while holding back the coarser dust. The aquatint box, essentially a chamber containing rosin powder, throws the powder up into the air in the chamber by means of a forced air system composed of a paddle wheel, a bellows, and compressed air. Larger particles of rosin dust fall more quickly; smaller grains float longer in the air. After activating the air source, the etcher waits until the coarsest grains of dust have fallen, and then opens the door in the box and places the plate inside on a wire screen. The plate is left in the aquatint box for only a few moments, until a sufficient quantity of dust has fallen on the plate to make a satisfactory aquatint. The aquatint box dusts more evenly and mechanically than either the rosin bag or sieve. Coarse grains of rosin dusted thickly on the plate produce a rough-grained tonal area; fine grains of rosin dusted too thinly produce an uneven tone.

When an optimum amount of powdered rosin has been evenly dusted on, the plate is placed on the hot-plate with care, in order not to disturb the rosin, and left on the stove until all the rosin has melted. This is a critical operation, and the etcher must watch the plate carefully. The rosin dust will change color from light brown to a shiny, almost transparent color. Occasionally a few specks of rosin dust are burned dark brown on the plate. When the dust has melted, the plate is removed from the hot-plate and allowed to cool. Each grain of dust that has melted on the plate is a tiny acid-resistant bead; rosin aquatint is a porous ground.

Acid attacks the plate in minute spaces between beads of melted rosin. In principle, 50 per cent of the plate should be covered with these beads and 50 per cent left uncovered. If there is still loose dust on the plate after it has cooled, that is an indication that the rosin has not melted sufficiently. If the rosin has melted too much, the beads may fuse to form an acid-resistant sheet that must be removed with a solvent such as shellac thinner, and then the rosin aquatint process must be repeated.

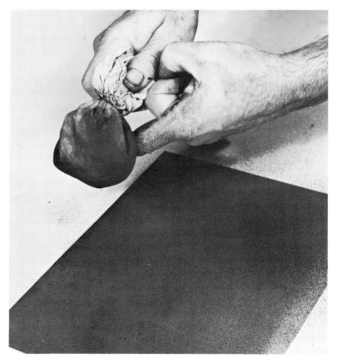

Applying a powdered-rosin aquatint with a cloth-bag sieve

Melting the rosin aquatint on a hot plate

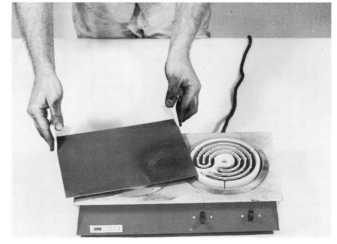

When the plate is suitably dusted and melted, the etcher can stop out any areas that he wants to protect from acid. Many etchers do this even before the rosin has been dusted. The aquatint is bitten in a relatively "slow," or weak, nitric acid solution of five parts water to one part acid. A nitric acid solution that is too "fast" might undercut the particles of rosin and lift them from the plate, which would destroy the evenness of the porous ground. For a light gray tone, five minutes or less in the solution may be long enough; for darker tones, sometimes as long as two hours is needed.

The rosin is removed with denatured alcohol, and then the plate is inked and printed. Often the first printing of an aquatint reveals a pebbly tone with many white flecks in the gray areas. For a darker, more even tone, the etcher may have to remove the ink with paint thinner and repeat the dusting, melting, and biting process several times. He should remove the plate from the acid from time to time to see if the rosin ground is still intact. If the nature of the design permits, the etcher can remove the plate from the acid after a few minutes, wash it in water and dry it, and then stop out the areas that are intended to print a lighter tone, replacing the plate in the acid to bite the areas he has left exposed.

Sometimes the tone on the plate is darker than the etcher anticipated, and darker than the needs of the design. Dark tone can be lightened with the aid of the scraper, the burnisher, fine sandpaper, and steel wool. Effects of shading and graduated tones can also be produced with the use of these tools. With practice and experience, the etcher learns to anticipate the proper tone for a specific design —rough-grained or close-grained, light or dark—and chooses the most appropriate materials and techniques.

Roast beef, mashed potatoes, peas, and a few brief remarks . . . , etching and aquatint, 16 x 20 inches, 1969, by Judith Hahn (Photo by W. B. Nickerson)

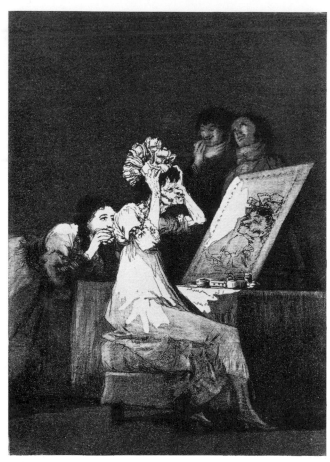

Hasta La Muerte, etching and aquatint, 1799, by Francisco Goya (Achenbach Foundation of Graphic Arts, California Palace of the Legion of Honor)

American Centennial, etching and aquatint by Leonard Edmondson

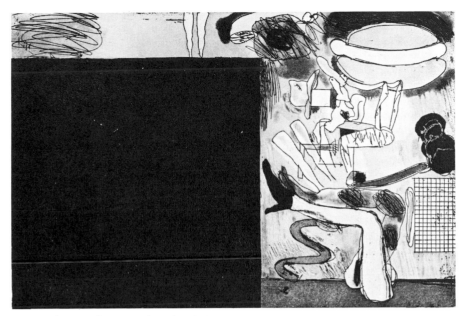

Legs, etching and aquatint by John Opie

Un Forgeron, aquatint, 17¾ inches x 11¾ inches, 1833, by Eugene Delacroix (University Art Museum, University of California, Berkeley, gift of Dr. and Mrs. Joseph Goldyne)

Spray-ground Aquatint

As a substitute for the traditional rosin or asphaltum powder ground, some etchers use a porous *spray ground,* an acid-resistant lacquer or enamel in a pressurized container. It can be used independently or to reinforce a rosin-ground aquatint. Spray ground is quicker to apply and does not require heating, but is less resistant to acid than the rosin ground.

The etcher may either stop out on the plate before a spray ground is applied or first lay a porous ground of spray drops on the bare plate, and stop it out later. The preferred procedure is to spray on a light coat, bite the plate in nitric acid for a few minutes, and then take it out and add more spray. These steps can be repeated several times if a dark gray tone is required, but spray-ground is particularly effective when a light to medium tone is the goal or when the etcher needs to avoid heating the plate. A plate should not be heated when the etcher does not want to run the risk of melting soft ground that he has included for textures, when he is using a long thin plate that could curl from the heat, and when a plate has been so coated with stopping-out varnish that heat might bake the varnish on, making it very difficult to remove.

When the spray ground is used to supplement rosin aquatint already melted on a plate, the plate is rebitten in nitric acid for a few minutes and then rinsed and dried. The spray ground, added over existing rosin ground that may be partially bitten or washed off, sometimes achieves a somewhat finer aquatint than rosin alone.

Applying a spray-ground aquatint

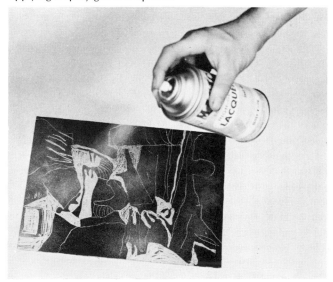

Lift-ground Aquatint

The lift-ground aquatint has two principal uses: (1) to produce an informal grainy texture, and (2) to produce a print that has the quality of brush drawing. The *lift-ground material* itself is a mixture of granulated sugar, liquid soap, black India ink, and water. Sometimes this mixture is used directly to produce grainy lines; sometimes it is boiled until it becomes a thick syrup that lifts clean. Usually the etcher stops out on the plate before the *sugar lift* is applied, but stopping out can be done afterwards (see below). When this mixture is applied to the plate with a brush, stick, or swab, the granules of sugar distribute themselves into informal, irregular patches that are easy to see because the black India ink colors the granules. The mixture should be a saturated solution of sugar and water. If the mixture is too thin and watery, the grains of sugar may be so sparse that they will not lift and expose the plate. If the mixture is too thick, the sugar may pile up into large clumps, and solid areas will lift that are too large to give the required grainy tone.

When the sugar mixture has dried thoroughly on the plate (this may take an hour or more) the entire plate, including the sugar, is covered with a coat of thin varnish or dilute asphaltum. This stop-out coat is applied with a soft brush; care must be taken not to disturb the grains of sugar. When the stop-out has dried completely, the plate is immersed in warm water and allowed to soak. The water dissolves the sugar so that the plate is exposed only where the grains of sugar were originally placed. The presence of liquid soap in the mixture makes the sugar lift more easily into the warm water. Sometimes the sugar lifts in a few minutes; sometimes it takes several hours of soaking and even an occasional rubbing action with the hand to make the sugar lift. Much depends on the size of the sugar particles and the thickness of the stop-out varnish. When the sugar has lifted, which exposes the plate so that the etcher can see the metal shine, the plate is taken from the water, dried, and examined. Sometimes additional stopping-out is necessary before the plate is ready to be placed in the nitric acid.

Sugar-lift areas that have lifted clean, that is, dissolved entirely, in the water usually bite smooth in nitric acid and therefore print light gray. If a darker tone is required for the lifted areas, the etcher may first bite the open places for a few minutes, then take the plate from the acid, dry it with a paper towel, add an aquatint ground of either rosin or spray lacquer to the open places, and return the plate to the acid for biting. The lift-ground aquatint method can produce a coarse-grained uneven tonal and textural area or, particularly if the sugar mixture has been boiled, can lift clean and smooth.

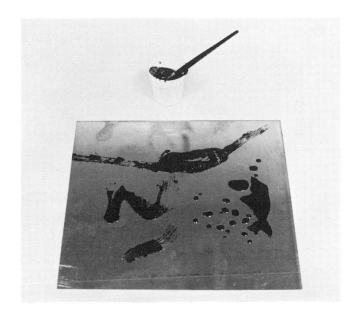

Applying a lift-ground aquatint with a brush. The lift-ground material is a mixture of granulated sugar, liquid soap, black India ink, and water

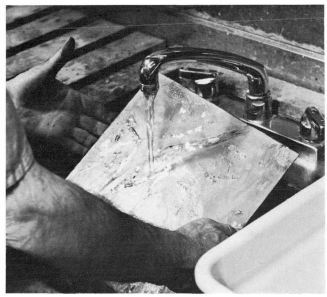

Washing off the sugar lift

Portrait of Bernard Malamud, lift-ground aquatint in five colors, 24 x 18 inches, 1970, by Karl Schrag

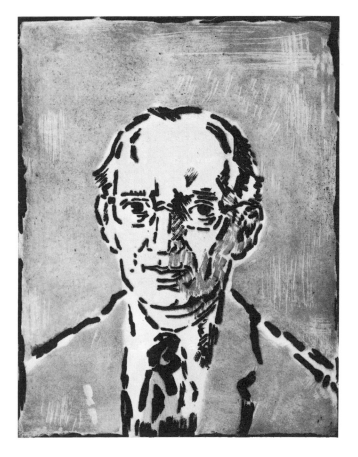

Sugar Aquatint

The *sugar aquatint* is another method for producing a coarse-grained tonal-textural area. The etcher first brushes a coat of dilute liquid asphaltum on the plate, and while it is still wet, sprinkles sugar on the plate in an even layer. A salt shaker or a coarse-meshed sieve will serve for this. Next, he warms the plate on a hot-plate to make sure the sugar sinks completely into the wet ground; after the ground has dried, he may stop out additional areas that are not meant to be exposed. If a light tone is required, the plate is bitten for only a few minutes; if a darker tone is required, it is bitten for a longer time.

The sugar aquatint process can be repeated several times in the same areas for special designs, or it can be combined with rosin-ground or spray-ground methods for very fine tones.

Sand Grain Aquatint

A coarse-grained tone similar to the sugar-aquatint tone can be achieved with the use of sandpaper, to make a *sand-grain aquatint.* The etcher first coats the plate with liquid asphaltum or any other hard ground, and when the ground is completely dry, places pieces of sandpaper, cut in the desired shapes, on the plate wherever this tone is desired. The plate and the sandpaper are run through the press under strong pressure. The hard ground will be penetrated by many minute scratches. If a denser grain is needed, the sandpaper can be shifted slightly and the plate rolled through the press a second time, or a third. Nitric acid will bite these diminutive scratches in the hard ground, and produce the sand-grain aquatint tone.

Scratch Tone

Without using acid, an effect similar to aquatint can be accomplished by attacking the surface of the plate directly. Under certain circumstances this can be done with sandpaper placed on a metal plate and rolled through the press, if the sandpaper is coarse enough and the pressure great enough. The imprint from the sandpaper will be pressed or scratched directly into the metal plate. Or scratches can be made on the plate by hand sanding. A power drill with grinding, brushing, or drilling attachments can be used to scratch the metal plate. Another way to pit the plate so it will hold ink is to sandblast it. Any and all of the scratch-tone methods suggested here can be used separately or in combination. The etcher is encouraged to discover other means for making scratch tones.

Mezzotint

Mezzotint is another traditional method for creating tonal areas. The *mezzotint ground* is a kind of scratch tone caused by scratching the surface of the plate with a tool called a *rocker.* This tool has a wooden handle and many sharp-pointed metal teeth set on a curved plane. The tool is rocked over the plate by hand, scratching the surface and raising a burr. Usually the etcher rocks the tool over the whole surface of the plate several times, vertically, horizontally, and diagonally, until the metal surface is abraded. If the plate is inked intaglio at this moment, it will print a velvety black. When the entire surface of the plate has been roughened by the teeth of the rocker, the etcher draws on it by scraping, flattening, and polishing the plate. With his drawing tools, the scraper and the burnisher, he works from dark to light by scraping and smoothing the mezzotint burr to gradually lighten areas in his design. The final print resembles a charcoal drawing—tonal areas are soft and gray, and edges of shapes are fuzzy.

Arise the Dead (Debout les Morts), etching, aquatint, mezzotint, and drypoint, 25½ x 20 inches, 1927, by Georges Rouault (University Art Museum, University of California, Berkeley, gift of Mr. and Mrs. Charles D. Clark)

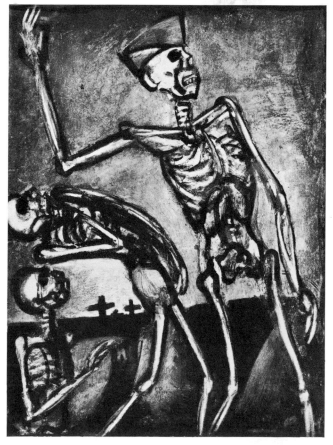

Des Oeufs, mezzotint by Mario Avati (Grunwald Graphic Arts Foundation, University of California, Los Angeles)

Soft-ground Tone and Texture

The soft-ground method is another popular means for creating tone and texture. It is different from the other tonal methods because the textures can vary from regular to irregular and because the ground never hardens. Aquatint methods always print a relatively even tonal area. Soft ground is always soft enough so that anything pressed firmly into it will pick up the ground when it is removed, thus exposing the imprint to the action of the acid.

To make a soft-ground texture, the etcher first must coat the plate with a soft-ground material, as described earlier in this chapter. Next, the etcher lays pieces of material that have a textural quality, such as cloth, lace, leaves, sandpaper, coins, string, crumpled aluminium foil, etc., on the soft ground. Any material can be used if it is flat enough to roll through the press, if it can be easily removed from the plate, and if it has a distinctive texture or shape.

If only slight pressure is needed, the etcher can press the material into the soft ground by hand or by stamping on it, but if more pressure is needed for a sharp impression, the plate is run through the etching press under reduced pressure. The ground is usually protected by laying a piece of cardboard over the plate.

When the textural materials that have been pressed into the soft ground are removed, they lift away the soft-ground paste and impressions of the material can be seen plainly on the soft ground. These impressions expose the metal plate, which is bitten in the acid. Before putting the plate in the acid, the etcher stops out all of the areas that should not be exposed to the mordant. The soft-ground method can be repeated as many times as necessary. Using this method, a variety of tones and textures can be quickly and easily attained.

Textured materials laid on a soft ground

Impressions in the soft ground made by the leaf, coins, wire, and papers

Palm of Love, soft-ground etching by Bettye Saar

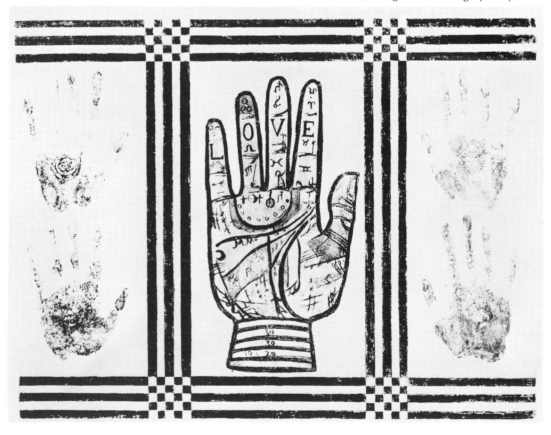

Kyoto Experience, soft-ground etching, 14½ x 23½ inches, by Paul Darrow (Photo by Charles Everts)

Frog and the Flies, soft-ground etching, 23¼ x 34 inches, 1969, by Ken Price and Ed Ruscha (Collection, University Art Museum, Berkeley)

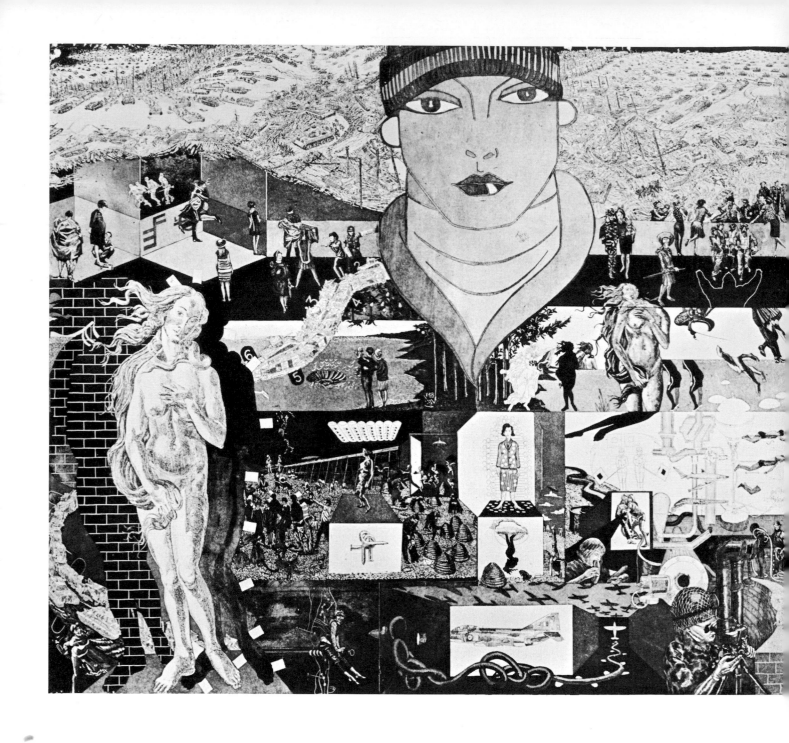

Roll Over, Bend Over, Sweet Nancy Marmalade, Mad Magazine
Bosch Strikes Again, etching by Ben Sakaguchi

2. Printing

Printing, the last step in transferring the image from plate to paper, is a very important process in the etcher's technical repertoire, and can be divided conveniently into three parts: (1) inking the plate, (2) wiping the plate, and (3) printing the plate. Printing can have a great deal of individual variation, especially with very complex plates that bear the marks of many etching techniques and different tools. The etcher needs both skill and experience, which is the best teacher, to print such plates successfully.

Serpentine Lady, etching, 8¾ x 17½ inches, 1968, by John Paul Jones

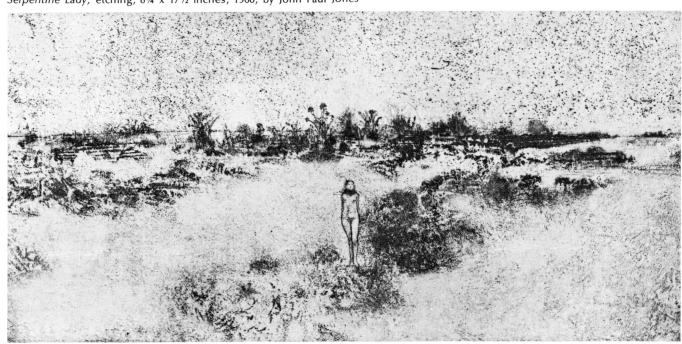

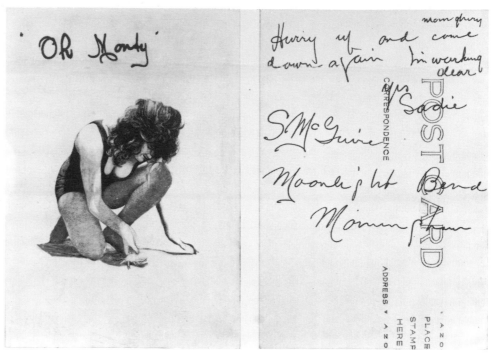

Postcard, intaglio etching, 17⅜ x 24¾ inches, 1964, by Thomas P. Coleman

Still Life, etching, 9⅜ x 9¼ inches, 1933, by Giorgio Morandi (Los Angeles County Museum of Art)

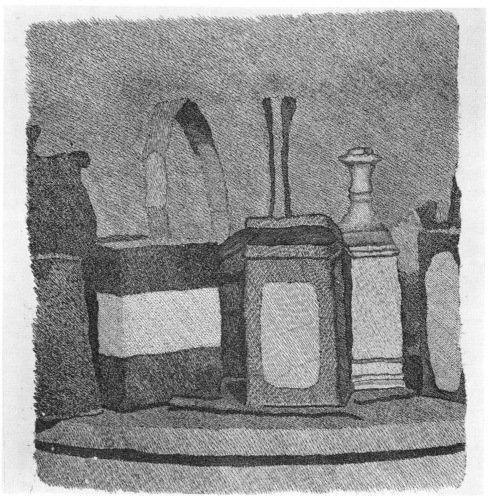

Inking the Plate

The plate has to be inked for each print. There are two basic ways to ink a plate: *intaglio* and *relief*. In intaglio inking, the most widely used traditional method, the etcher forces ink into the scratches and valleys—the low places—of his plate. In relief inking he places a thin layer of ink on the raised surfaces—the high places—of the plate, and avoids the low places. Relief inking is usually done with a soft rubber roller.

Relief inking is more common to the wood block printer's art. Therefore, in the detailed description of inking, wiping, and printing that follows it is the intaglio process that is being described. The etcher works with a plate that has been scratched with tools or bitten in acid until it has low places that will trap ink. Deep incisions and rough textures hold more ink and print a darker tone; shallow incisions and smoother textures hold less ink and print a lighter tone.

The ink that the etcher uses is very important to the final look of the print. The traditional ink color is black, but there are many distinctly varied blacks—in color: blue-black, brown-black, in tone: intense black, gray-black, and in texture: soft, stiff. Ink colors such as sienna, umber, and sepia are also used. Many different brands of good quality black etching ink are sold in artists' supply stores, in tubes or cans. However, the etcher can make his own ink by mixing together Frankfort black dry pigment and heavy plate oil such as burnt linseed oil. These ingredients must be stirred together on a piece of glass with a palette knife or putty knife until oil has reached all of the particles of the dry pigment. A common mistake is to use too much oil and not enough dry pigment. This too oily ink will wipe out of the scratches and crevices of the plate causing the image to print only faintly.

The ink is applied to a slightly warmed plate by means of a cardboard *scraper* or a *dabber*. The scraper is used to scrape the ink across the plate in several directions until all of the low places are filled. The dabber is made of felt that has been rolled into a cylinder of convenient length and circumference and held in shape with rubber bands or string. It is used in a rocking or circular motion to scrub the ink into the incisions on the plate. Scraping and dabbing are equally effective.

Inking a plate in intaglio, using a dabber

Inking a plate in intaglio, using a cardboard scraper

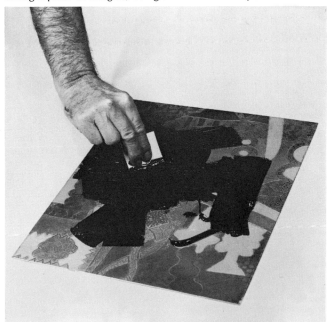

Mornings with Judd, second-state etching and engraving, 18 x
24 inches, 1970, by Peter Milton

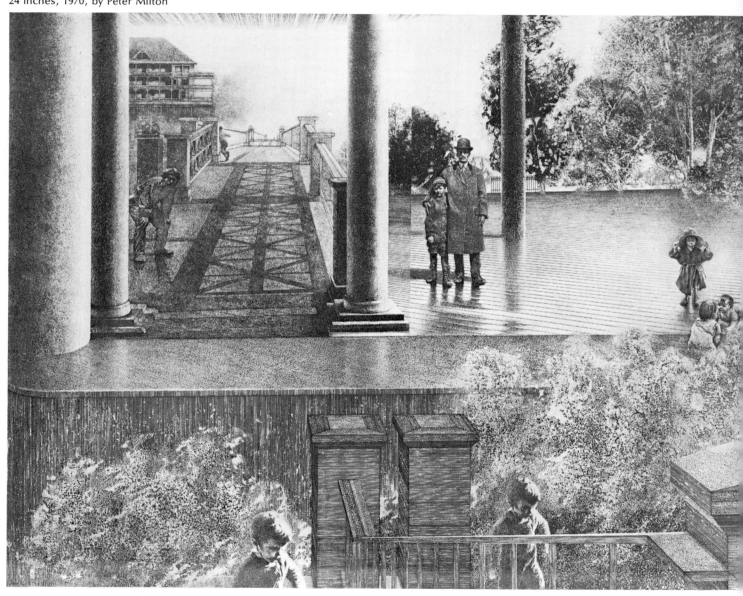

Wiping the Plate

After the ink has been spread over the entire plate and into all the lines and valleys, the plate is wiped. Wiping refers exclusively to the plate that has been inked intaglio; if the plate is rolled up, or inked, in relief, no wiping is necessary. To wipe the plate the etcher can use *tarlatan,* an open-weave, heavily sized cotton, cheesecloth, paper towels, the palm of his hand, or any combination of these wipers, depending on the desired look of the print.

The object is to wipe the surface of the plate clean without removing the ink that is lodged in the holes and crevices. Usually the etcher begins his wiping by using tarlatan rolled up into a ball and wipes with a circular motion. He continues to wipe with other materials if a cleaner wipe is needed. Hand-wiping is usually done with the aid of a small amount of finely ground chalk dust, to absorb excess oil. Drypoint drawings are usually hand-wiped exclusively, to protect the fragile burr. After the last wiping, the etcher should wipe any excess ink from the edges of the plate.

A plate that is wiped dry and clean has very little *plate tone* on the surface and will print crisp and sharp. A stain of ink intentionally left on the surface of a plate is called a plate tone, and the resulting print will be darker and softer.

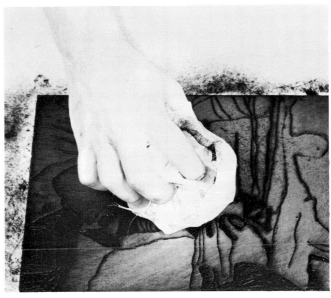

After a plate is inked in intaglio, it is wiped. Here tarlatan is being used

After the first wiping, the same plate is often wiped cleaner with paper towels

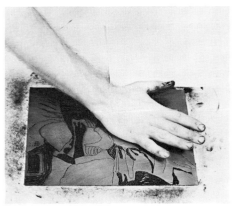

The final wiping is done with the hand and a small amount of finely ground chalk dust

Printing the Plate

For printing the plate, or "pulling a print," the etcher needs to know about etching papers, etching presses, and printing techniques. Paper is the traditional surface for both intaglio and relief printing. A good etching paper should be thick and soft and not too fragile to be soaked in water. All etching papers are treated with a sizing of glue. There are many excellent domestic and foreign papers suited to the needs of the etcher. These papers vary from hard to soft, from smooth to rough, from thick to thin, and in a range of tones from white, cream, and buff through gray. The etcher should choose the particular paper that brings out the best in each print, and cut it to a size that allows a generous 3- to 4-inch margin on each border of the print. This will give adequate room for handling, trimming, and matting.

Next, the etcher soaks the paper in a tray of clean cold water until some of the glue size has been dissolved. This makes the paper more receptive to ink and responsive to pressure. Some papers absorb water like a blotter and need to be dampened only for a minute or two, while other papers should be soaked for a longer period—ten minutes to half an hour. The etcher will learn by experience the properties of each paper. If a paper has not soaked long enough it will not pick up the ink from the plate in sufficient quantity to make a good impression; if it has soaked too long it will become so soft and fragile that it will tear when handled or stick to the plate under pressure of the press. When the paper has been properly dampened, it is removed from the tray of water and placed between clean white blotters for a few moments until all the surface water has been absorbed. At this point, the paper is ready for printing.

An intaglio plate is printed on an etching press, a special press that squeezes the paper into the ink-filled hollows in the plate. The press consists of a solid bed, made of steel, iron, hardwood, or plywood, with two metal rollers, a turning handle, and a frame that supports these pieces. Usually the handle drives one of the rollers, either top or bottom, but some presses are made so that the handle drives the bed between the rollers. The handle can be attached directly to the roller by an axle, or it can turn the roller through a series of gears. Presses are sometimes directly driven by a star-spoked wheel, sometimes geared for easier turning and driven by a fly wheel, and sometimes driven by an electric motor. Pressure screws on both sides of the frame adjust the amount of force the rollers will apply to the plate and the evenness of the rollers. The etcher must be careful to observe that the pressure of the top roller is even from side to side. If the pressure is too light the print will be uneven, some of the lines may not print at all, and the general tone of the ink will be gray. If the pressure is too tight the roller may distort the plate, tear the paper, or damage the etching press.

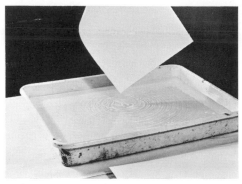

Soaking etching paper in water before printing

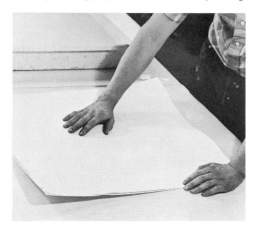

Blotting the paper between two clean, white blotters to absorb the surface water

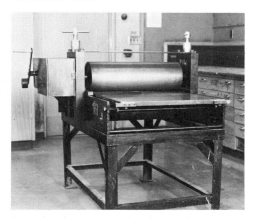

Geared etching press. The plate and paper are cranked between the bed of the press and the roller. Pressure is adjusted by the handles at the top

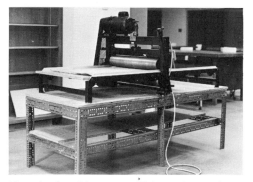

Motorized etching press. This works on the same principles as the geared etching press but no hand-cranking is necessary

The etcher will learn by experience how to adjust the pressure to give good results.

Before printing, the etcher should check the edges of the plate to see if they are sufficiently beveled, or rounded, to avoid cutting the paper or the blankets. A few strokes with a file will remove any sharp edges. Then the inked plate is placed face up on the bed of the press. Next the paper is removed from the blotters and placed on the inked plate. Finally the plate and paper are covered with printing felts, or blankets, which should be of good quality wool, resilient and finely woven. Most printers use three blankets: a thin, finely woven facing blanket; a pressed, medium-weight middle blanket; and a pressed, thick top blanket. Extreme care should be taken not to cut the blankets by rolling sharp or overly thick objects through the press, nor to make creases in the blankets by laying them down and not pulling them tight.

When the felts are in position, the etcher is ready to roll the plate through the press, and pull the print. The bed—supporting the plate, paper, and felts—is rolled through the press under considerable pressure, which squeezes the felts against the paper and the paper against the inked portions of the plate. Not only is the ink transferred from the metal plate to the paper, but the paper becomes embossed. When the plate has been rolled through the press, the blankets are folded back and the paper is carefully pulled from the plate.

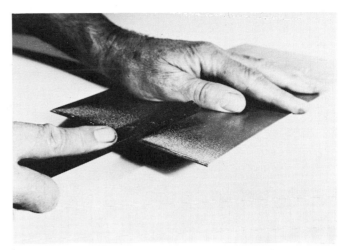

Beveling the sharp edges of the plate so they will not cut the paper as it passes through the press

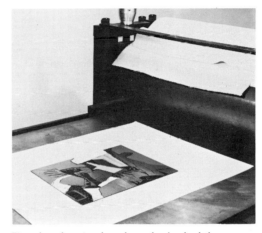

First the plate is placed on the bed of the press

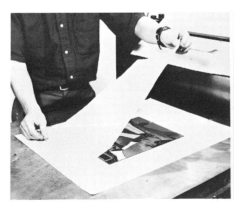

Then the paper is placed over the plate

Felts are placed over the paper

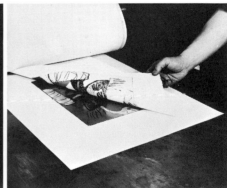

And the proof is pulled

After printing, the plate is cleaned with paint thinner, while it rests in a bed of sawdust

Buste d'Homme, etching by Pablo Picasso (San Francisco Museum of Art)

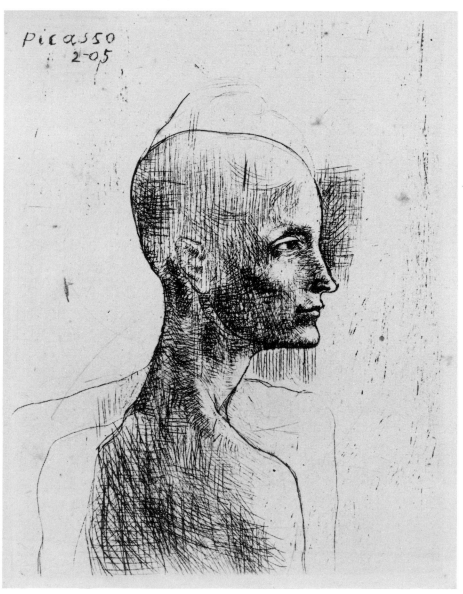

This first print is called a "proof," and the great surprise for the beginner is that it is a left-right reversal—a mirror image—of the drawing originally made on the plate. With a critical eye for art and craftsmanship, the etcher views the proof. There may be more work to be done on the plate, by repeating processes already used or introducing new ones, or the quality of the printing may have to be adjusted. If the print is too dark and smudgy, the fault lies in a too deeply bitten plate or in not wiping enough ink off the plate. If the print is too light and the lines are too gray, the fault lies in a too lightly bitten plate or in wiping too much ink off. If the print is too grainy and textured, it may mean that the facing blanket is not finely woven enough. If there are white gaps in the black lines, the pressure of the press should be increased. When both the image produced by the plate and the quality of the printing are satisfactory, the etcher is ready to print, number, and sign an edition. Some etchers prefer to dry their etchings by taping them on the wall with butcher's tape, others simply lay them down flat and let them dry.

After the printing process is completed, the plate should be cleaned by removing the ink from the lines and pitted areas on the plate with paint thinner and an old tooth brush. If the plate is not going to be printed again for a while, it should be covered with a light coat of grease to prevent corrosion, wrapped, and stored away. Before using again the grease must be removed with acetone. Prints should be stored flat on a shelf or in a drawer.

After a print has been pulled and has dried, it is ready to be matted. Most exhibitions recommend a hinged mat of white cardboard. Depending on the size of the etching, the margin of the mat may be 2, 3, 4 inches, or even larger. Often the bottom margin is somewhat larger than the other three. After the outside dimensions of the mat have been established, a window is drawn on the mat board. This window must be large enough to leave a margin of ½ inch or more of black etching paper showing around the platemark, which gives the artist room to sign, number, and title his print. The window is cut with a mat knife and a metal straightedge, and then the front mat, the one with the window, and the back mat are placed on a table and attached to one another with a strip of 1-inch masking tape across the top. The tape is on the inside of the top border, and when the cardboard facing mat is folded down over the cardboard backing, it acts like a hinge. Then the print is carefully centered behind the window, and, when the print is in place, the window mat is lifted so that the print can be taped to the back mat with small pieces of masking tape or butcher's tape. The completed mat is a sturdy, clean protection for the print.

Satyr and Maenad, etching, 1967, by Ernest Lacy

Taping the hinged mat. The tape, which is on the inside, acts like a hinge as the window mat is laid over the back mat

The print is carefully centered on the window mat, and then matted and mounted to the back mat

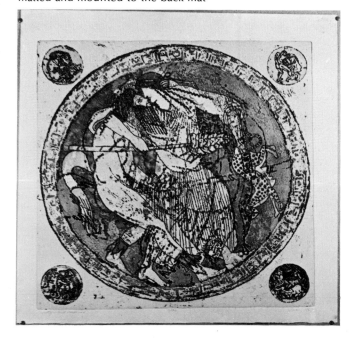

Check List for a Traditional Etching Workshop

The basic workshop equipment, tools, and materials listed below are used for the traditional techniques that have been described in the first section of the book.

Basic Workshop Equipment
 Etching press (roller type)
 Hot plate
 Sink
 Water supply
 Acid tray
 Paper soaking tray
 Printing felts

Basic Workshop Tools
 Etching needle
 Drypoint needle
 Burin
 Scraper
 Burnisher
 Hard rubber brayer (roller)
 Soft rubber brayer (roller)
 Dabber or cardboard squares (2 x 2 inches)

Basic Workshop Materials
 Zinc plate
 Copper plate
 Nitric acid
 Black etching ink
 Etching paper
 Blotters
 Ball ground (hard ground)
 Liquid asphaltum
 Soft ground
 Varnish
 Orange shellac or other stop-out
 Tarlatan
 Newsprint paper
 Paint thinner
 Alcohol (denatured)
 Shellac thinner
 Acetone
 Hand cleaner, waterless
 Paper towels
 Mat board
 Mat knife
 Masking tape

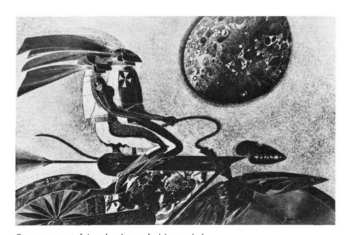

Baroque, etching by Joseph Mugnaini

Columbia River/Flood Stage, intaglio etching, 11⅜ x18¾ inches, by Gordon Gilky

48

MODERN TECHNIQUES IN ETCHING

The chapters under this heading are mainly concerned with methods and materials of color etching. They are intended to provide the etcher with information about some new processes and encourage experiments. Modern etching techniques reflect the impact of technology: new products, new materials, new equipment. Technical experimentation encourages artistic growth and shapes a new kind of imagery. The ultimate concern of technical information is a more perceptive etcher.

Oriental Image, five-plate color etching, 25½ x 75 inches, 1969, by Mauricio Lasansky

3. Basic Methods of Color Etching

The major trend in modern printmaking is toward an increased use of color. While the traditional etcher did, in fact, use a limited range of color in his prints: warm black, blue-black, sepia, burnt umber, etc., still, the extensive use of color in etching is a relatively new development. There are several alternative paths to making a multicolor etching. The basic methods are: (1) to ink intaglio in several different colors on the same plate, (2) to combine intaglio and relief inking on the same plate (with the aid of stencils), and (3) to use two or more plates. Or the etcher has the option of combining two or three of these methods in a single print.

Although these are only the rudiments of color printing, it is important to remember that there are no absolute procedures to follow in the relatively new and unexplored field of color etching. The future of color etching will be as vital as etchers are inventive.

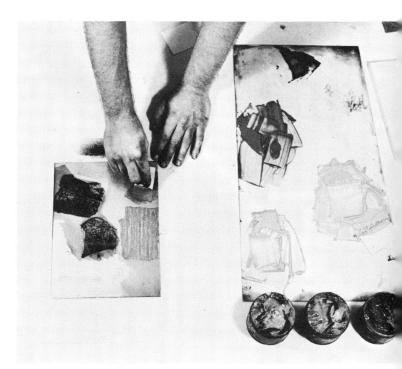

Inking à la Poupée

Intaglio-inking more than one color on a single plate is called inking à *la poupée*. The procedure is to ink and wipe each area before going on to the next color. Some etchers wipe the exposed plate, while others cover the parts of the plate that are not being wiped with pieces of paper to protect them from being stained. The plate can be inked with colored etching ink, lithographic ink, or oil paints. For intaglio printing the etcher ordinarily uses etcher's ink, which (although it comes in a somewhat limited range of colors) is particularly effective since it is intense in chroma. However, printer's ink, lithographic ink, and oil paints are effective substitutes. The wiping is accomplished using tarlatan, paper towels, cheesecloth, or hand-wiping. The etcher usually tries to reduce the range and amount of color stain in order to reduce color blending and smudging.

Inking a *là poupée* can be useful depending on the nature of the design. It works best when the areas that are to be inked with different colors are reasonably far apart. It does not yield results that can be repeated with any uniformity, since each color stains the plate slightly around the area where it is wiped. However, this is an easy and useful method, since the plate only has to be run once through the press to produce a multicolored etching.

Paysage Arizona, color etching, 1960, Max Ernst (Achenbach Foundation for Graphic Art, California Palace of the Legion of Honor)

Composition IV, color etching, 1957, by Pierre Soulages (Achenbach Foundation for Graphic Art, California Palace of the Legion of Honor)

Inking a *là poupée*

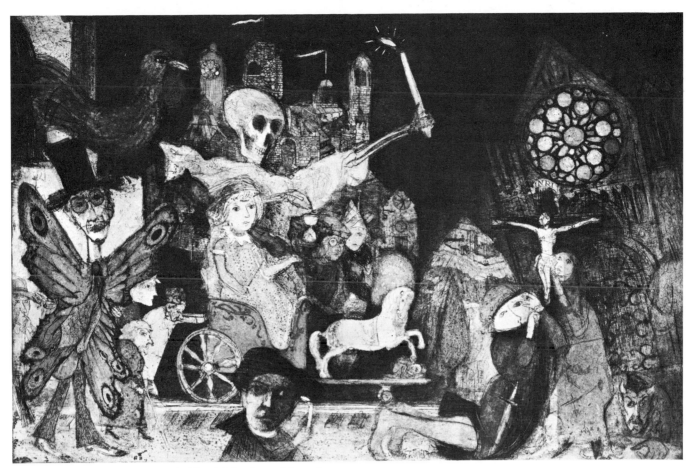

All Children Must Be Accompanied by Adults, four-plate, color poupee, intaglio etching, 23¾ x 35¾ inches, 1971, by David F. Driesbach

Combining Intaglio and Relief: Stencil Method

Multicolor printing on a single plate, done by combining both intaglio and relief methods with the aid of stencils, is a widely used process. It exploits a broad range of inking possibilities, and, if the stencils are cut accurately, the placement of relief color can be very precise. Ordinarily the plate is first inked intaglio in black or a color. Sometimes the plate is wiped very clean, sometimes a distinct plate tone is left. A clean plate produces brighter and purer stenciled colors; a toned plate makes the stenciled colors duller and softer. After the plate has been wiped intaglio, it is ready to have the relief colors rolled on.

Stencils for the relief color are made by printing the intaglio plate on a piece of dry stencil paper. Glazed paper is very satisfactory for this use. Then the stencil is cut with a mat knife, stencil knife, or single-edged razor blade.

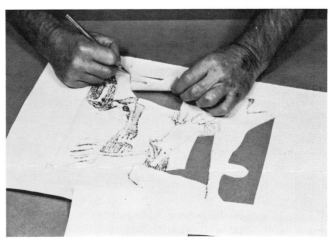

Cutting a stencil. Multicolor printing on a single plate can be done by combining intaglio and relief inking with the aid of stencils

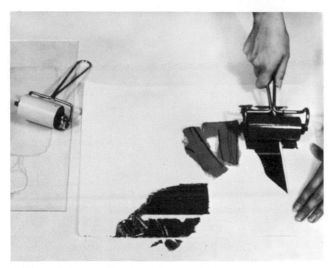
Rolling relief colors on through a stencil

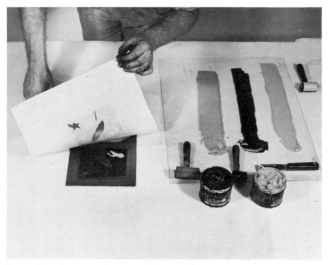
Removing the stencil. Stenciled areas of color are clearly marked on the plate

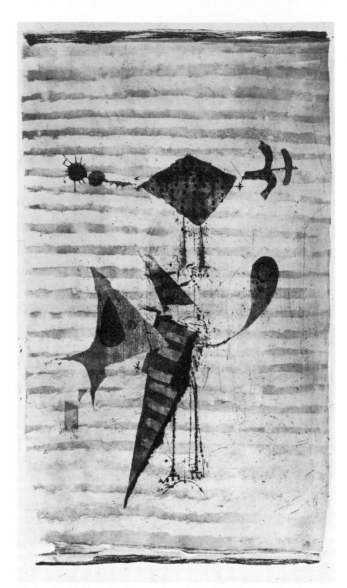
Birds with Yellow Background, etching by John Friedlander (San Francisco Museum of Art)

Kaleidoscope Portrait Series No 5, color etching by Russel Gordon

Because the design from the plate has been printed on the stencil paper, it makes accurate cutting easy, and ensures precise placement of the stencil (or sometimes several stencils) on the plate. Wherever holes have been cut in the paper, the plate is exposed, and colored ink is rolled in relief on to these exposed places with a soft rubber or gelatin brayer. Many relief-rolled colors can be applied by using many different stencils, but the etcher must plan the sequence of his stencils carefully to minimize the danger of the stencil picking up the plate colors rolled on over the first stencil. When all of the colors have been rolled on, the plate is ready to be printed. The advantage of this method is that a multicolor print can be made employing only one plate rolled just once through the press. Amazingly complex color designs can be made in this fashion.

54

There is another effective method of multicolor printing requiring only one roll through the press. The etcher cuts a plate up into pieces, intaglio inks them separately, and then reassembles them to take a print. Depending on the nature of his design, the etcher can bite his plate first and then cut it into sections, or he can cut the plate into shapes first and etch them later. The metal can be cut with a jeweler's saw, a jigsaw, or a band saw, depending on the complexity of the individual shapes, and whether or not some of the metal can be wasted. The etcher must file any ragged edges on the plate to prevent them from cutting the paper or the blankets. Since each piece can be inked in a separate color without in any way interfering with its neighbor, the etcher can use as many colors as there are pieces.

When the individual pieces have been inked, he reassembles them on the bed of the press to fit together tightly, like the pieces of a jig-saw puzzle—in which case a white line usually shows between the pieces—or to float on a field of white etching paper. If the design calls for the pieces to be placed at some distance from one another, the etcher must establish a means of *registration*, or correct alignment, that will guarantee a reasonably accurate edition. Registration techniques are discussed below. The color results of this method can be made increasingly complex if the individual pieces are inked intaglio and then rolled relief. When a plate is inked intaglio in one color and rolled relief in another it makes a two-color print. If stencils are used, several colors can be rolled on in relief.

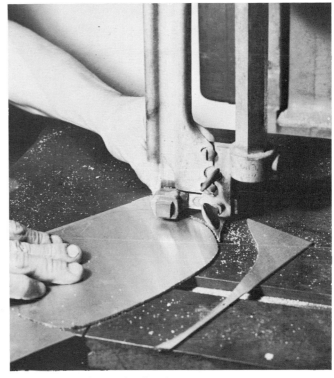

Cutting a zinc plate with a band saw

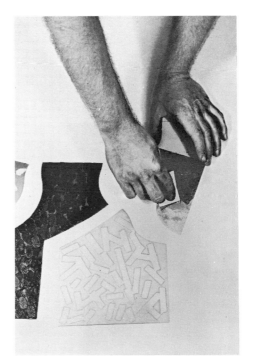

Inking each piece of the cut plate

Registering the cut pieces on the bed of the press

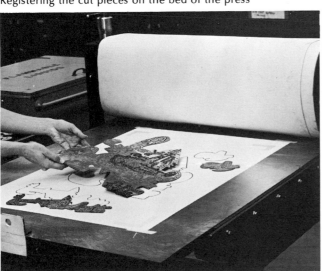

American Crane, color intaglio from assembled plates by John Hannah (Comsky Gallery, Los Angeles)

Ten Part Poem Etching, color etching by Ynez Johnston

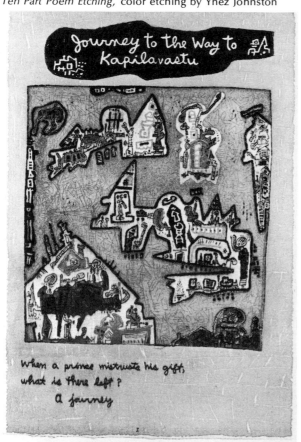

Daily Double, color intaglio from assembled plates, 26 x 30 inches, 1971, by Norman Schwab

Intaglio Printing: Superimposed Plates Method

When a separate plate is used for each color, the etching must be run through the press a number of times—each plate printing over the image of the last plate on the paper—until the print is completed. The plates are identical in size and shape, but etched differently. Often, when one color is over-printed on another, blended colors will result. The sequence in which the colors are printed, therefore, will affect the final result. Lightest colors are often printed first, brightest colors last. Since there is no limit to the number of plates that an etcher can use, and no limitation to his choice of colors, it is clear that the etcher, inking exclusively in the intaglio method, can achieve a very complex result.

Even more complex color orchestration can be achieved through the superimposed-plate method if relief colors are added to the intaglio colors on each of the several plates.

Aida, color etching, 36 x 48 inches, by Ernest Freed

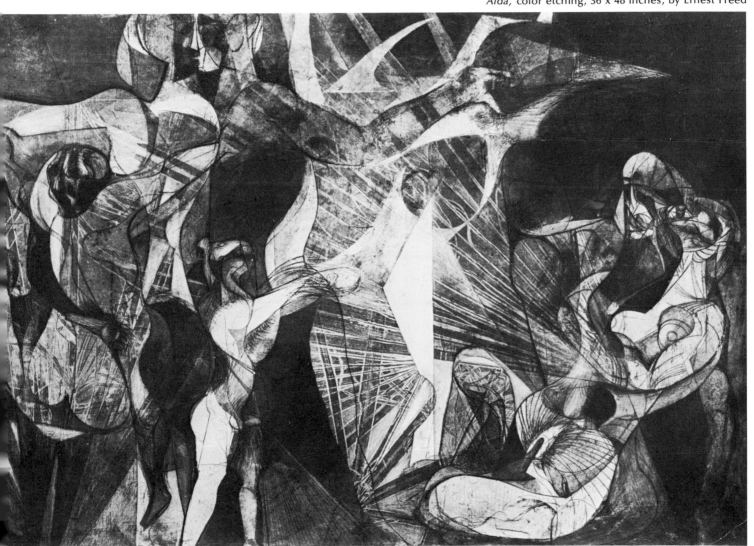

Foursome, assemblegraph, by Tom Fricano

Everybody Loves Sarah, etching and aquatint by James Grant

Assemblegraph Method

When relief methods are used exclusively, cardboard makes a serviceable substitute for a metal plate. The cardboard is sprayed with lacquer, enamel, or plastic to make it impervious to oil and water. Then it is cut up, inked with a roller, and reassembled for printing. A cardboard relief print is usually characterized by broad flat colored areas.

When relief and intaglio methods are combined, the cardboard is printed in relief, and the other materials are printed in intaglio. Strongly embossed objects, found or made in the studio, can be first inked intaglio and then in relief to produce an even more complex color effect. The chosen objects must be approximately the same height as the cardboard. If the etcher intends to assemble all the pieces to print in one roll through the etching press, he should cut holes in the cardboard pieces for inserting the other objects, which are intaglio-inked separately. Such combination prints, inked separately and assembled on the bed of the press, are easy to make and offer diversified color results.

Registration: By Feel

In color etching, the problem of *registration* must be solved whenever more than one plate is involved, either when one plate has been cut up and inked separately, then reassembled, or when the same sheet is printed with superimposed images. Since the method of printing etchings requires that the etching plate be placed face up on the bed of the press, and the paper laid face down on the plate, the etcher cannot register a second, superimposed printing by sight, but only by feel or by some mechanical system.

Some etchers do, in fact, register by feel. To register the overprinting, they carefully lay the paper face-down on the second plate and, avoiding excessive shifting of the paper, adjust the embossed edges of the first print until they fit the edges of the second plate. This is a somewhat rough but nevertheless adequate system.

Mechanical Registration: Wet-on-Wet

The mechanical systems for registration usually involve marking the position of the first plate on the bed of the press so that subsequent plates can be put on the bed of the press in exactly the same place. Different systems of registration are used depending on whether the paper dries between printings or not.

Registration by keeping the paper under the roller or taped to the bed of the press is only effective when printing wet-on-wet. Mechanical registration of the plate on the bed of the press is equally necessary for wet-on-wet and wet-on-dry methods. For this reason, it is advisable to have all the plates inked and ready before the first one is printed so that the paper will not have time to dry and shrink excessively. A satisfactory way to keep the paper in place while one plate is removed and replaced by another is to leave one end of the paper caught in the blankets still under the roller. Blankets and paper are thrown back over the roller while the first plate is removed and a second plate placed in the identical position. The paper thus

trapped cannot move and will fall on the second and third plate with accurate registration if the plates are placed in the identical position on the bed of the press. The paper can also be held secure by taping one end of it firmly to the bed of the press and not removing the tape until all the plates have been printed.

Mechanical Registration: Wet on dry

If the etcher wishes to print wet on dry, he must remove the paper from the blankets after the first plate has been printed, and allow the ink to dry overnight or longer if desired. Before printing the next plate, the paper must be redampened and reregistered, either by feel or by a mechanical marking system. In one mechanical marking system used to ensure accurate registration the etcher marks the bed of the press with paint or tape to show exactly where the next plate must be placed. In another system he cuts a hole in a cardboard mat to fit the plate or plates, and marks the bed of the press with the exact placement of the mat. The mat is then either removed and replaced for each run through the press, or permanently taped to the bed of the press until the printing has been completed. The etcher also marks the mat to indicate where the dampened paper should be laid.

All wet-on-dry registration is vulnerable to error because of the expansion of damp paper and the shrinkage of dry paper. Although it is possible to dampen the paper for exactly the same length of time before each printing, it is difficult to estimate the amount of shrinkage during drying. One of the visual characteristics of multiple-plate etching is that the plate marks on the paper often reveal problems of accurate registration.

Untitled (IV), color aquatint, 23½ x 40½ inches, 1971, by Larry Zox (Published by Brooke Alexander Inc., New York; photo by Nathan Rubin)

Untitled, color etching by Conner Everts

Confrontation, etching on 2 plates, 1968, by Michael Mazur (Photograph by Clemens Kalischer)

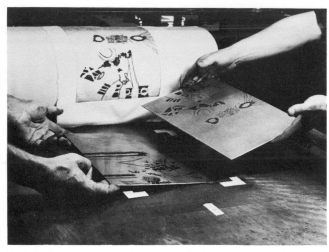

Registration marks taped to the press bed ensure that each successive plate in a multiple-plate etching will align properly with the previous impressions

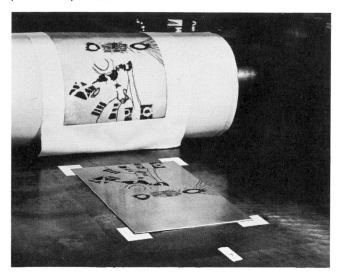

Second plate registered on bed of the press

After each plate is exchanged, the paper must be re-registered. Note how the paper falls on the tape with the registration mark, which can be seen in the two preceding pictures

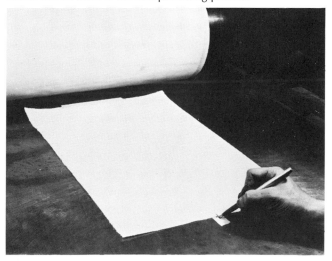

Hawaii I, six-color etching by Rudy Pozzatti, 1971

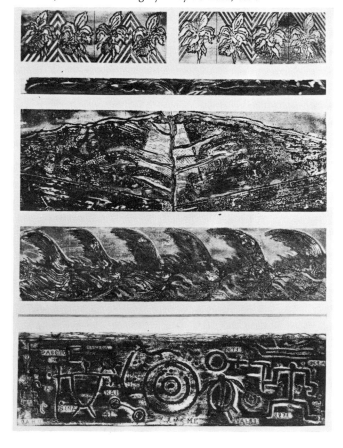

Color Etching: Technical Demonstrations and Color Plates

Pages 65-72, color plates
Pages 61-64, 73-75, descriptions

1. *Flower Power.* The irregular edge of this zinc etching plate was cut with a metal-blade band saw. The design is based on a number of drawings made to scale. To begin making the plate, a ground of liquid asphaltum (California Ink Company, Litho Asphaltum Varnish) thinned with benzine was brushed on, and the plate was warmed on the hot plate to smooth and dry the asphaltum ground. A line drawing was made into this hard ground using a commercial etching needle. The plate was then placed in a tray of nitric acid of normal strength for approximately 1½ hours.

Next, several soft-ground textures were applied. The soft ground paste was made by mixing equal parts of Standard Oil Co. RPM Wheel Bearing Medium and liquid asphaltum. The soft-ground textures were not all laid on the plate at the same time, but in different stages of biting, which required stopping-out, at each stage, all areas of the plate that were not intended to be exposed to the mordant, but were not already protected by the soft ground. The first texture was made from a piece of embossed paper torn from a wall-paper sample book (shown along the bottom). Then the two Coca-Cola cloth arm patches were applied (these show reversed writing at right side of design). Later, lace cloth and corrugated cardboard were used, and the final soft-ground textures were made with coins. Some further textures were made by stamping acid-resistant liquid asphaltum on the plate with rubber stamps.

Next, rosin dust was applied with a cloth bag to produce aquatint tones. The gray tone in the upper middle of the plate was originally bitten dark, and later it had to be lightened with the use of a scraper, burnisher, and fine sandpaper. The blackest blacks were made by repeating the complete rosin aquatint process three separate times, each time leaving the plate in acid about ½ hour. A total of 1½ hours of biting time was required for the black tones.

The plate was inked by combining intaglio and relief inking. The intaglio inking was done first, using black etching ink (Graphic Chemical and Ink Co. Etching Black No. 514). The relief inking, superimposed over the intaglio-inked plate, was done using stencils, rollers, and oil-paint colors. To make the stencil, the plate was inked and printed on the flat side of dry glazed paper, which left a clear, accurate image of the design. The areas to be inked were then cut out of the stencil using a single-edged razor blade. Soft gelatin rollers were used to roll on the oil colors in relief in a palette of cobalt blue deep, yellow ochre, chromium green, viridian, and cadmium red medium.

Three separate stencils were used. The first stencil contained all the yellow ochre areas and the two chrome green Coca-Cola arm patches. The second stencil contained the two blue lace areas. The third stencil exposed the viridian green corrugated paper and all of the cadmium red coins. Before it was rolled on the plate, each color was first rolled out thinly on a piece of glass with a separate gelatin roller for each color. In order to print the plate in full color, it had to be rolled only once through the press.

For each subsequent inking, the black was not removed, but the oil paint that was rolled relief on the surface had to be wiped off clean with paper towels before the plate could be re-inked with black and re-rolled with oil color in preparation for the next printing.

This etching was printed in the conventional manner on a geared fly-wheel etching press using three felts and a tissue paper facing cover. The position on the bed of the press was: tissue paper (to keep the paper clean), the inked plate, etching paper, again tissue paper (to absorb size and moisture), fine felt, medium felt, thick felt. The edition was printed on Murillo paper.

2. *Maryhelen.* When I made this picture from life of my wife Maryhelen, I worked directly and quickly in color etching, avoiding elaborate preplanning of the image and following spontaneous impressions and associations. To do this I used the following methods (others may have used similar techniques for similar purposes, although not to my knowledge). (1) I cut a copper plate for each color, making sure that all plates matched exactly. (I used 3202

cold rolled industrial copper, for reasons of economy.) In this case there were four plates—red, yellow, blue, and black—none of which was intended to be a "key" plate. (2) I rolled soft ground onto each plate. Because I had to take all plates home to work from the model, I used an expanded metal framework I devised to transport them without touching the soft-ground surfaces. (3) I prepared to draw into soft-ground in a traditional way: I taped down the top of a sheet of thin tracing or tissue paper, and marked the place underneath where the plate would sit.

Then I placed the first plate down, lowered the paper flap, and drew with a yellow pencil. I lifted the flap, replaced plate 1 with plate 2, drew with a red pencil, replaced plate 2 with plate 3, and drew with a blue pencil. (In this case, there was a fourth black plate requiring no drawing.) Plates were shifted back and forth as the drawing required, and the final result was a full-color drawing on one sheet of paper, with each separate color impressed in the ground on a separate plate. (4) The plates were then bitten in mordant to a desired depth, cleaned, and if the drawing is very complete, printed. (In this case, I went on to steps 5, 6, and 7 before printing.) (5) I put an aquatint ground on each plate. (6) I painted acid directly onto the plates in traditional spit-biting techniques, mentally calculating the color mixture that would be printed, based on my previous experience. But I expected some shifts and surprises. In this case, I took the plates home again, for a second sitting. I used a solution of equal parts nitric acid and water for spit-biting, guided by the image already bitten into each plate. (7) I washed each plate, and stopped out some areas with varnish. Then I used the aquatint ground still on the plate for biting in mordant, timed by a watch, to obtain the desired tones. (In this case, I did the initial stopping-out while my wife was posing, again using bitten areas for guides, but vitalizing the graphic separation of the different plates by overlapping along the edges of forms thus giving spatial light. I expected still more surprises from this technique.) (8) I cleaned and printed the plates, taking the initial proof by the wet-on-wet method. The final prints were allowed to dry between colors, which were printed one over the other, starting with the lightest. In this case, the print was complete in one state, although reworking can be done at this point, if necessary. Inks used were manufactured initially for Tamarind by Sinclair and Valentine: stone permanent rose red, stone permanent yellow, and stone monostral blue. The black ink was made at UCLA from bone black, vine black, and plate oil. Registration was achieved by laying the first color proof over the second plate on the press and carefully feeling corners and edges until plate and paper matched—primitive but good enough.

3. *Voyage to the East.* This etching involves four separate zinc plates, cut by a saber saw. During the cutting, the surface of the metal was protected from being scratched by the glider on the saber saw by cardboard pasted on the zinc. The largest plate was cut together with a corres-

ponding plate. The two plates in this zinc "sandwich" were separated by a thin piece of cardboard. More intricate places on all four zinc plates were cut with a coping saw and smoothed with a file.

The grounds used were hard ground, aquatint, and litho crayon. The acid was a strong solution of nitric. The aquatint areas and litho-crayon-ground areas were bitten several times in the acid.

The color was applied to the large central area (which is made up of two superimposed, identical plates) using both intaglio and relief methods. The first plate contained the yellow and green areas especially. On the duplicate plate the black and red were inked intaglio and other colors were rolled in relief. The small plate at the top was inked intaglio with a grayish black color made by mixing white and blue with black etching ink. The small plate at the bottom was first inked with black etching ink and then a color was rolled on the plate. A stencil was used to protect the other parts of the plate.

Since the large central plate consists of two duplicate plates, one printed over the other, the problem of registration had to be solved. This was done by placing a piece of paper on the bed of the press, laying the first large plate on the paper in the proper position for printing, and then marking around it with a pencil. After this first plate was printed, it was removed and the duplicate plate placed exactly in the marked area. At this time the two small plates were laid on the bed of the press, and the three plates printed on this second run through the press.

The etching was printed on Reeves BFK paper using Charbonnel etching ink for the black lines and areas, and oil paints for all the color lines and areas.

4. *Borderline.* The outside border was cut from mat board. The gray border with a light-yellow aura was inked as follows. First, the light yellow was rolled on with a small, 2-inch brayer. It was rolled approximately 1 inch from the inner edge outward. Then a larger, 3-inch to 4-inch brayer was used to roll a gray ink over the entire surface. In order to create this halo effect the mat must be rotated while the brayer is kept in the same position, that is, with the gray on the outer edge. While rolling the gray, some of the light yellow will be picked up by the gray roller and form the aura.

The orange square is also cut from mat board. It is rolled up with orange ink, and set into the gray mat.

The center is made up of a car gasket, four printed circuits, eight coins, and four aluminum washers. The gasket was rolled with gray ink, and set in place. Then the four circuits were inked and wiped in the intaglio process, followed by a brown roll-up. These were set in place around the gasket. The center coins in the gasket were inked intaglio with black, and then rolled with gray. The four coins on the orange were inked intaglio in red, then rolled with purple. The aluminum washers were rolled in black, and set in place.

The bottom row of coins with aluminum washers were inked as described above, but blue, green, and red were used.

All inked objects were assembled on the etching-press bed. Dampened paper was placed over these objects, and then the paper was covered by several felts. The press pressure should be adjusted somewhat lighter than for etchings because the materials vary in surface hardness as well as height. The print was then run through the press, and the felts pulled back. The print was removed gently by lifting from corner to corner. All inking processes were repeated for each print in the edition.

The assemblegraphic print process developed by Tom Fricano is a new form of color printmaking that requires no plate in the traditional sense, thereby allowing great freedom and ease in color printing. In this process, individual pieces are inked separately in as many colors as desired, placed directly on the press bed instead of being glued to a plate, covered with damp paper, and run through the press. This allows maximum freedom in composition and color, for changes can be made while inking and assembling. This method virtually eliminates having to roll through the press more than once.

This assemblegraph was printed on Arches paper using Charbonnel black etching ink and Sinclair-Valentine litho-ink colors for the cardboard roll-up.

5. *Taro Red* is a combination of three separate components: photo-etching, collagraph, and embossment. The collagraph component (top portion with arrows) was built from ⅛-inch tempered Masonite and railroad board (poster board). Tempered Masonite was used since it has little tendency to warp. Working drawings on tracing paper were transferred to the Masonite and poster board. The arrow shapes were cut at a bevel with a mat knife, and the entire shape was glued with PVA to the Masonite, which had been precut roughly to shape with a saber saw, and then finished and beveled with block plane and files. Glue was applied to both surfaces, allowed to set for a short time until tacky, and then placed under boards and weights until dry. The plate was then sprayed on the face and edges with four coats of Kerpro appliance white lacquer, sanded lightly with 400 wet-dry sandpaper between coats. The last sanding was wet.

The "cloud" embossment plate was cut from two layers of Crescent antique white mat board. Two pieces were temporarily laminated together with double-faced tape and cut with little or no bevel to get a better impression. The top layer was then removed, an aperture cut exactly the size of the etched plate, and the two layers were then glued together with PVA and placed under weights until thoroughly dry. The plate was then sprayed with three coats of lacquer on both sides to seal against moisture from the damp paper and to prevent warping. The plate was sanded lightly on the edges between coats. In addition to its function as an embossment, the plate also provides a shimmed template to receive the etched plate; the thickness of one layer of mat board corresponds to the thickness of 16-gauge zinc, and two layers of mat board correspond to the thickness of the Masonite. By providing a flat printing surface over all of the components, this eliminates printing problems that might be inherent in differences in thickness between such dissimilar materials.

The etched plate, "the eye," was conceived as a drawing on matte acetate with acetate ink and a striped, textured sheet of pressure-adhesive micro-type. The acetate drawing was then transferred to a piece of photo-sensitized 16-gauge zinc (Revere) by exposing for 2½ minutes on a Nu-Arc flip-top platemaker. The plate was then developed and washed out, dried and checked for flaws. Pinholes were stopped out with shellac and the plate was etched for a short time in a fast nitric acid bath to slightly relieve the intaglio areas that were open. This gives a more durable surface for intaglio printing. An aquatint was laid and melted. After further stopping-out of fine lines, I gave a second, longer etch in a slow bath.

Arches white imperial was selected for printing. Each sheet was dipped in water and placed between blotters wrapped in plastic sheeting, to sit overnight. A half-and-half mixture of Graphic Chemical No. 1014 Vince Chemical black and Leber Collagraph black No. 1 was used for inking the intaglio. This mixture is especially good for a collagraph because of the adhesive quality of the collagraph ink but was also used to ink the etched components of the print, because the other ink has good opacity and color and eases the wiping. The collagraph plate was inked with a No. 12 stencil brush and wiped with tarlatan. The final wipe was by hand.

The red was rolled in relief with an 8-inch gelatin brayer through a clear acetate stencil that protected the edges of the plate. The ink is Shiva oil-base block printing ink in a half-and-half mixture of two reds, hues 6 and 7½.

The plate was then placed on the bed of the press on a sheet of newsprint bed paper marked in pencil with paper and plate outlines for accurate registration. The embossment plate was also placed on the bed at this time. The etched plate was then inked with the same inks and wiped in essentially the same way as the collagraph plate. It was placed in the aperture of the embossed plate. Finally, after the printing paper was set in place and the blankets smoothed, the combined plates were run through the press.

6. *Oedipus.* The four copper plates were cut with a metal band saw, the inside cuts were made with a jeweler's handsaw. The plate incising methods involved the conventional acid-biting techniques of soft ground, hard-ground line etching, flat-bite etching, and aquatint in that order.

I did a variation of the soft ground technique by reversing the bite as follows. Soft-ground technique traditionally is negative biting, that is, it produces intaglio-bitten lines. Instead, I produced positive, relief textures in portions of the plate by "inking" the intaglio soft-ground textures with soft ground, and then wiping the relief. When the plate was bitten, what had been lines and textures in relief bit past what had been intaglio, thus putting them into relief.

The inking of the plate was done in the viscosity-color

printing method. All colors were printed in one operation. The three inks—yellow, red and a blue-black—were conditioned with varying amounts of linseed oil. The intaglio color, blue, had very little added linseed oil; the relief-roller color, yellow, had quite a bit of added oil; the soft, intermediate-level-roller color, red, had no added oil. This produced three inks that would reject each other.

The plate was bitten to five levels. Two rollers were obtained for inking; one of the rollers was soft (15 degrees shore) the other hard (45 degrees shore). With this preparation, the inking was done as follows. (1) The intaglio was inked and wiped conventionally with a blue-black ink. Where it was concentrated and dense, the color was blackish, where thin, a light blue. (2) The hard roller passed over the plate with an oily yellow ink. Since it was hard, the roller inked only the upper relief surfaces. (3) A soft roller with lean red ink (very little oil) was rejected by the yellow relief ink as it passed over the plate because of the differing oil content of the two inks. However, because the roller was soft it penetrated the lower intermediate levels and deposited red on these uninked areas. The result was a large range of color mixture because the red ink mixed with films of the other inks at different levels. Also the differing levels could be reached only by different pressures of the soft roller, which left differing amounts of red ink at each level. Therefore purples, greens, and off-reds were produced along with the pure reds, yellows, and blues.

This method was duplicable, and an edition of 50 plus 15 artist's proofs was nearly identical.

7. *Vortex*. A combination of red and blue inks produced this optically patterned effect. The viscosity-color method was used, similar in principle to the method described by Dick Swift on page 68.

8. *Amarina*. The basic plate was made of illustration board. Its edges were beveled with a mat knife. The major form areas, including larger shapes and dominant linear features, were developed by using acrylic modeling paste manipulated with wide putty knives and stiff-bristled utility brushes. The smaller, interior forms were developed with pieces of paper and with sandpaper glued to the surface. The entire plate was first inked intaglio in blue-black, and wiped, and then each of the other colors was laid on the plate in relief with brayers and stencils. The collagraph plate was then printed in the etching press. The first state was run in 1966, and the second-state edition was run in 1967.

9. *Sky Blue*. This etching is the result of a collaborative effort of four etchers. All four were involved in making the plates, deciding on color, inking the plates, deciding how the plates should be assembled, and printing the etchings.

Three separate photo-plates were used. The "sky" plate was made from a 35mm photo-negative enlarged to a 5 x 7-inch negative transparency. A halftone-dot screen was also used. This plate was inked in relief by rolling on a light blue color with a soft rubber brayer.

The transparency for the "boat" plate was made from a magazine picture by using sticky acetate to transfer ink from the picture. This plate was inked intaglio with black etching ink.

The transparency for the "water" plate was taken from a magazine picture as described. This plate was inked intaglio and hand-wiped.

The three plates were assembled on the bed of the press and printed all at once on Arches buff paper.

10. *How the West Was Won*. The central image was taken from a 35mm color slide and a superimposed 150-line halftone screen. The positive transparency was exposed on a 16-gauge presensitized zinc plate and then developed. The developer is manufactured by the same company that produces the zinc plate. The plate was etched in a slow nitric acid bath.

The central plate was cut to shape and then placed on a clean, unsensitized 16-gauge engraver's zinc measuring 16 x 20 inches. The outer plate was scored and cut, and acted as a frame for the central image plate. After proofing the central plate, I decided that the background overpowered the central figure, and I stopped out the girl-and-horse figure, as well as the lower foreground, with shellac. The remaining background was etched down with an open bite in a stronger nitric acid bath.

The outer plate was laid with a coarse aquatint and bitten in a slow nitric acid bath. After the first etch, the plate was re-aquatinted with a fine aquatint, and the edges were masked out with a vinyl plastic tape. Tape was also applied vertically and diagonally to create the subtle ray pattern in the frame. The plate was re-etched in a slow nitric acid bath.

The outer-frame plate was inked in a mixture of burnt umber and rose madder. It was then wiped with a rag and finished with hand-wiping. The central-image plate was inked a la poupée in the following sequences. The horse and hat were inked in etching black, and rag-wiped. The foreground was inked in a combination of viridian green mixed with a small amount of etching black, and rag-wiped. The sky background was inked with a half-and-half mixture of cobalt blue and viridian green, and rag-wiped. Finally, the entire plate was hand-wiped to bring out the over-all textures, and then the figure of the girl was inked in rose madder mixed with a small amount of etching black.

The first few impressions were taken on Arches white

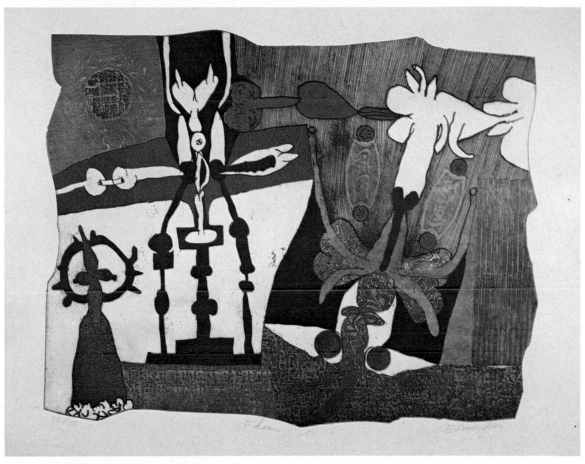

1. *Flower Power*, intaglio and relief color, by Leonard Edmondson

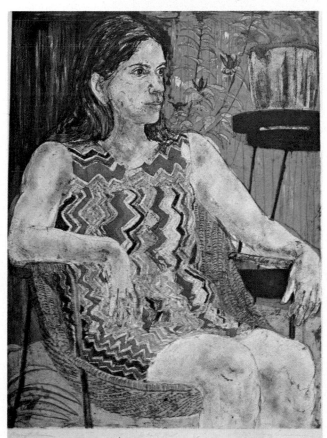

2. *Maryhelen*, multiple-plate color etching, by Ray Brown

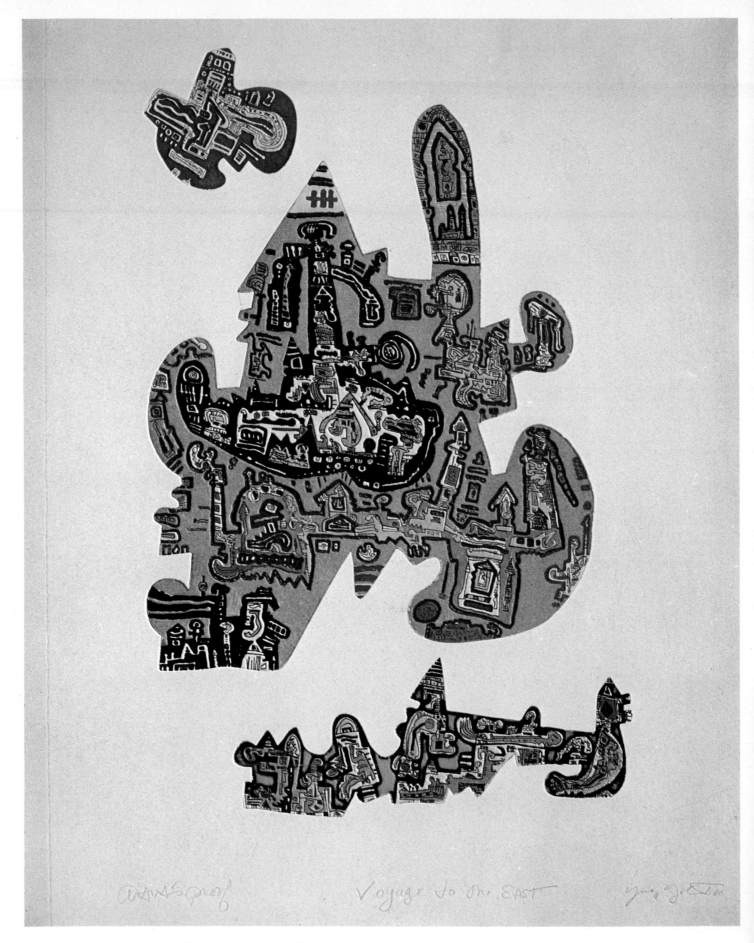

3. *Voyage to the East,* intaglio and relief color, by Ynez Johnston

4. *Borderline,* assemblegraph, by Tom Fricano

5. *Taro Red,* intaglio and relief-color photoplate and embossment, by Dennis Beall

6. *Oedipus,* viscosity color, by Dick Swift

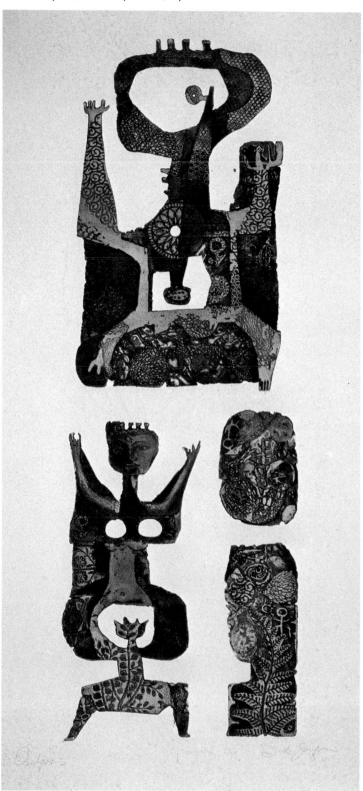

7. *Vortex*, viscosity color, by Stanley William Hayter

8. *Amarina*, collagraph, by Karl Kasten

9. *Sky Blue*, photoplate etching, by Cite Ltd., Pioneer Press Club (Corwin Clairmont, Shiro Ikegawa, Gordon Thorpe, Leonard Edmondson)

10. *How the West Was Won*, photoplate and etching, by John L. Ihle

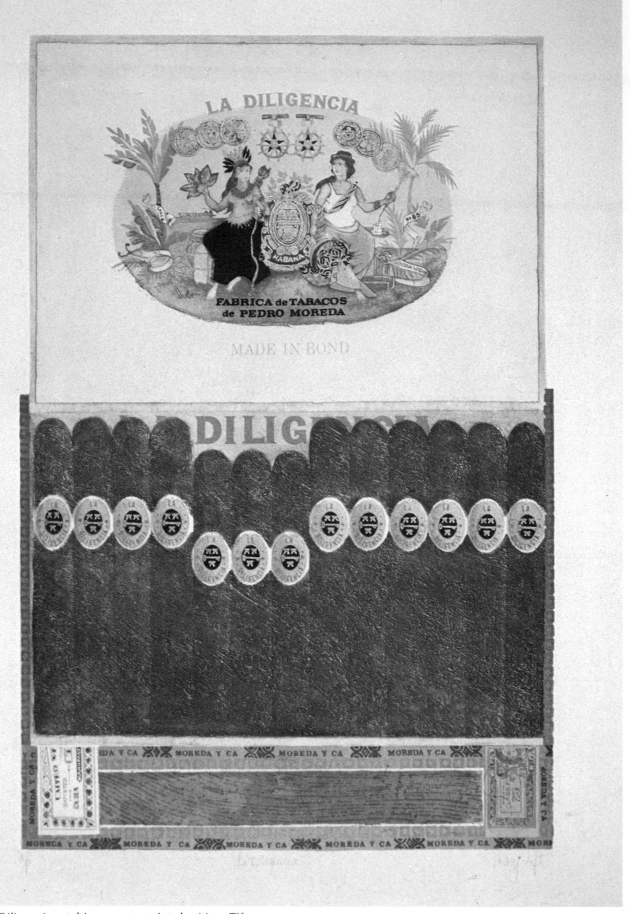

11. *La Diligencia,* etching screen-print, by Mary Tift

12. *Brown Trout,* 4-point color-separation etching by Shiro Ikegawa

14. *Column Series III,* 3-D color and mixed media, by Bong Tae Kim

13. *The Last Poet No. 3,* multimedia print, by Bob Evermon

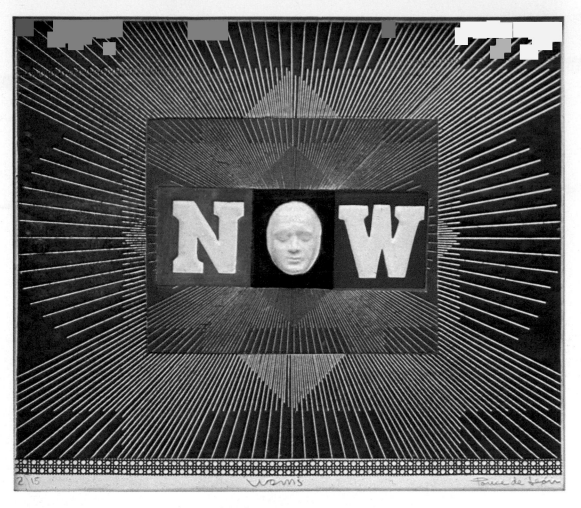

15. *There is a Time . . . ,* embossed photo-plate etching, by Michael Ponce de Leon

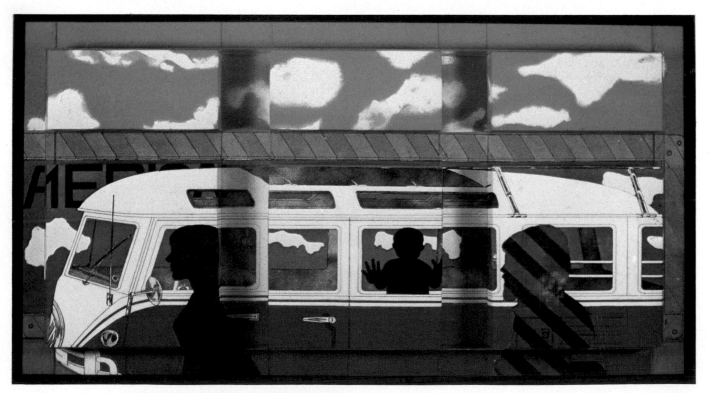

16. *September,* assembled-plate etching, by Shiro Ikegawa

handmade paper, but the white embossed line between the two plates showed a slight break, so the etching paper finally selected was Rives BFK since it has a little more stretch and is less likely to break under heavy embossing.

11. *La Diligencia* was printed from two zinc plates and thirteen silk-screen stencils. The glue stencils were handmade; lettering was rub-down type applied to the screen by pressure. When the glue is dry, the type is removed by regular solvent.

All plate work was done with the metal—shaped to the contours of the cigar box—in one piece. Before printing, the lower portion with the revenue stamps was cut away to make two plates. This was done because it is the only part that is inked in black and also because it helps to give a sharp edge to the cigar box.

The cigar area was etched first. Crinkled aluminum foil was pressed into a soft ground to get the desired texture. The finer lines were etched and blocked out in an asphaltum ground, and returned to the acid to etch the medallions in the oval, the gold areas of the cigar bands, and other areas more deeply. Finally, the tonal areas of the box cover were aquatinted.

Ink was applied with varying sizes of bristle brushes, daubers, and rollers, depending upon the size of the areas to be inked. The tarlatan was used, and the inked areas hand-wiped. Inking was done in the following order. (1) A bristle brush was used to apply burnt umber to the women's hair and to the tobacco leaves. (2) Gold ink (bronze powder in medium-weight Winstone's plate oil) was applied by brush to medallions and cigar bands. (3) By brush and roller a mixed ochre ink was applied to remaining uninked areas of cigar-box cover and to the edges of the box. (4) A mixed, ochre/raw umber ink was used for the cigar area and worked in with a dauber. (5) The small, separate plate was then inked in black. (6) Stencils were cut to conform to the shapes of the medallions and to the ovals on the cigar bands. A small gelatin roller was then used to roll red on the ovals and burnt umber on the medallions.

The two plates were butted together and printed in a single roll through the press on a sheet of white paper, Arches cover.

When the prints were dry the screen stencils were printed in the following order. (1) A light blue tint to cover the upper oval. (2) A deeper blue for one woman's dress, some of the foliage areas, the revenue label, the stars, feathers, and *Made in Bond*. (3) An opaque pink ink for the woman's sash and the roses. (4) Red ink for the other woman's dress and feathers, the roses, and the stars. (5) A yellow-green in some parts of the oval area and for the foliage. (6) A transparent ochre to cover the entire cigar area except for the cigar bands. (7) A screen of transparent black to give dimension to the cigars. (8) A yellow-gold bronze ink for the box border and the lettering *La Diligencia*. (9) A darker green-gold bronze for the pattern on the box border for the *La Diligencia* on the cigar bands. (10) A second red screen for the red on the box border

and for *Fabricos de Tabacos de Pedro Moreda.* (11) A cocoa-brown for the wood panel on the cigar box. (12) A transparent black for wood grain on cigar-box panel and to add dimension to the women's skirts. (13) An orange seen in the oval area.

12. *Brown Trout* is one of a series of autobiographical color etchings based on a camping experience in the High Sierras in 1971. I took a 35mm Kodachrome positive transparency of the brown trout and used it to prepare four separate Kodalith transparencies: black, yellow, magenta, and cyan. I used my own equipment in the Pioneer Press Club Workshop, and determined the basic factors by making a black printer without filter.

The aperture was f16 for a two-times enlargement; the screen was Kodak Gray Contact Screen Neg. 65 SQ.; the film was Kodalith Ortho Film Type 3 (2556). I used an exposure time of 36 seconds with 13 seconds flash with YZ filtered safety light. The film was developed in Kodalith Super AB for 2 minutes and 45 seconds at 70° F.

Color-separation chart

	black	yellow	magenta	cyan
aperture	f16	f16	f16	f16
filter	CG506 factor 1	47B, blue factor 25	57A, green factor 3	25A, red factor 3
screen	Kodak Gray 65 SQ.	same	same	same
screen angle	45	90	75	105
film	Kodalith Ortho type 3, 2556	same	same	Kodalith Pan, 2568
flash	13 sec. YZ filtered safelight	same	same	none
developer	Kodalith Super AB	same	same	same
developing time	2 min. 45 sec. 70° F.	same	same	same

All four printers were developed with Kodalith Super AB, for 2 minutes and 45 seconds, Kodak Rapid Stop for 10 seconds, and NACCO Fix for 10 minutes. Next I assembled all four Kodalith transparencies for registration. I placed them on a light table, and adjusted them for accurate registration of dots. Then I pierced a hole in each of the four corners of the frame with a needle that penetrated all of them. When the transparencies are exposed to the arc lamp, the pierced holes will show on the light-sensitive plates, indicating where the plates should be trimmed.

The color separations on Kodalith film were transferred to commercially prepared light-sensitive Micro Metal 16 gauge zinc plates. Exposure time to the Nu Arc lamp may vary somewhat, but the basic exposure time that I used was 5 minutes. After the plates had been exposed I placed

them in the Micro Metal developer for 13 minutes. Then I flushed off the developing fluid with a generous flow of water, and heated each plate on the hot plate for a few minutes until the coat was hardened and more acid-resistant.

I etched the plates for approximately 15 minutes in a jet-spray acid bath to produce a halftone etch for relief inking. I inked each of the four plates in relief using the color for which it was prepared: yellow, magenta, cyan or black.

To register the plates on the press for accurate overprinting I cut a window hole the exact size of the Micro Metal plates in a piece of single-ply illustration board. I taped the board to the bed of the press. The four inked plates were placed in this window hole one at a time and printed in this order: yellow, magenta, cyan, and black. I printed on dry etching paper to avoid the problems of shrinkage. The etching paper was taped to the bed of the press so that after lifting it would fall back into its original place during printing.

13. *The Last Poet No. 3* is a multimedia print that combines two litho runs, as well as one intaglio, and one silk-screen. I used heavy-weight German etching paper.

The red dots and black rectangular shape at the very top of print were the first printing. It was done with two small rollers and a stone drawn on with autographic ink and brush.

The second run was also a litho run, but it required much more preparation. A photo image was taken from a photoengraving made from a halftone using Kodak KMPR. The photoengraving was inked with litho transfer ink and printed onto litho transfer paper (Gum label paper). The transfers were then arranged together, and some drawing lines were incorporated, at this point, with autographic ink and pen. The whole circle was transferred to the stone. This method is somewhat freer than shooting the halftone directly on the stone. Once the photo image was secure, I engraved fine lines around the edge of the circles.

To engrave on a lithograph stone, the area must first be etched with 10 drops of nitric acid in 1 ounce of gum arabic, buffed down with cheese cloth, and left to stand 10 minutes. Next, I took a half-damp sponge and removed about one-half to three-quarters of the gum film and buffed the surface again. At this stage, the stone looks as if there is no gum left on it. Using a sharp needle, I scratched just hard enough to remove a little stone dust, and then I filled the lines with printing ink applied with a rag and buffed down to a black stain over the surface of the drawing. I sponged the surface with water, and rolled it up with a leather roller.

It's possible to add further engraved lines by repeating this process, but using gum without nitric acid. It's important not to get the lines too deep or they will not print. Some engravers build the ink up out of the scratch by adding rosin to the surface of the lines and then adding more ink, then rosin, and then ink again. It is possible,

at this point, to transfer the engraving to transfer paper and from that onto another stone. This would allow it to print easier because everything is on the top surface of the stone.

The large flat area with the 12 circles in it was drawn with autographic ink, and above that a water wash so that it would fit over the first printed rectangular shape. Three colored rollers were used in the second printing.

The third run was silk-screen. For this, a stencil was cut to a slightly smaller shape identical to the black flat area. Flocking glue was screened on and rayon flock was put on right away. I rolled a roller over the flock to secure it well. After the glue dried, I brushed off any loose fibers.

The last run was a viscosity intaglio run. The shape on the bottom was cut out of copper and etched at three different levels in nitric acid. The plate was inked in tan, black, and blue, and printed on dry German etching paper. (Because of its softness, it is possible to print on this paper without dampening it.) I use dry printing because of registration.

The pressure was increased very slowly through many runs back and forth on a press with very thick felts. It was important to run the press rollers only over the intaglio part of the print in order not to flatten the flocking.

14. *Column Series III.* (1) Cardboard-relief process was used for the red, which is printed first, in ordinary etching ink over the total surface of the German etching paper. (2) The linear square images were etched on zinc plates and printed on top of red. Opaque blue ink was used. (3) The prints were cut, folded, and glued onto light-blue colored cardboard. This light blue was applied directly on cardboard with a roller. (4) All the inks used are IPI etcher's ink.

15. *There is a Time . . .* The inspiration for this print came from seeing a photomicrograph of a paremcium cell revealing such an astonishing geometric perfection that I felt compelled to make two photographic enlargements of it, in two different sizes. The negatives were then placed over a zinc plate coated with a photo-resist solution, and then they were photosensitized by exposure to an arc light. The plates were developed with K O R and dyed with K P R and backed with varnish for stronger acid resistance. The paramecium-image transfer was etched with ferric chloride for greater refinement.

The letters in "NOW" were cut with a jigsaw out of a 16-gauge zinc plate and subsequently aquatinted. My own "death mask" in the center was modeled separately out of wax and then cast in bronze in order to get a ¾-inch, bas-relief mold.

The inking and printing of this collage was done in the following sequence. (1) The larger plate of the paramecium was inked intaglio with yellow ink. The lines in the smaller plate were left uninked. (2) The large plate was then sur-

face-rolled in blue purple, and the smaller one in red purple. (3) The inner square section in the large plate was rolled in gold through stencils. The smaller replica was inked in warm blue through another stencil.

The three sections of the "NOW" plate were inked intaglio in blue, black, and red. The magenta bottom band that came from a perforated commercial screen was also surface rolled, and finally a thin plastic band of the same dimensions was rolled in blue and placed under the screen to fill in the perforations with the same blue during the printing.

This collage construction was printed with a hydraulic press of my own invention. The press exerts 10,000 pounds of pressure, and is operated with the help of a hydraulic pump that compresses vertically instead of using the traditional turning action of a roller on a flat bed. Usually only one operation is needed in all my printings, no matter how many colors or plates, but in this print two were required. All the flat plates were printed all at once, one over the other, with all their edges well beveled to avoid white, inkless borders. The lower, perforated narrow band was printed at the same time.

The embossment of the small head was done by another stamping over the first printing without mashing any previous high relief. To print such a deep embossment, a special kind of paper was required. It was made by hand, out of linen, by paper-specialist Douglass Howell. To push the paper into the deepest concavities, a counter mold of wet pulp was forced into the mold by the pressure of the machine. To reach areas where the press was unable to penetrate, I went over the back of the paper with a burnisher and forced it into the extreme depressions. To retain such a relief shape the paper was dampened before printing with a sponge full of water in which plaster of Paris and Knox gelatin in a pure form were dissolved. When dry, this solution hardens the paper and helps retain its sculptural form.

The framing of this print, which is part of its concept, brings another dimension. Four mirrors, made out of 2-inch-wide plexiglass bands, were glued together inside and around the plastic box that serves as a frame at a 45-degree angle to plane surface of print. By this device the sculptural "death mask" is reflected on the four mirrors from its bottom, top, and profiles. Simultaneously, the image of the onlooker, reflected on the mirrors, becomes part of the total experience.

16. *September.* This etching was made in two separate sections: a sky section consisting of 7 zinc plates, and a Volkswagen section consisting of 23 plates. Each section was first printed flat, then cut and pasted together, and finally folded, mounted, and framed.

The sky section was made by first assembling all 7 zinc plates together in the position in which they appear in the final print. They were all aquatinted simultaneously, using rosin powder and a sieve, and then the rosin was melted on a hot plate. The plates were re-assembled, and cotton, spread over the entire surface of the plates, was pushed and pulled and torn to make cloud-shaped spaces. These spaces were coated with enamel from a spray can until a solid layer of acid-resistant enamel was put down. When the enamel had dried, the cotton was removed from the rest of the plate, exposing the rosin aquatint.

The linear image on the Volkswagen section was made by coating all 23 assembled plates with liquid asphaltum. When the asphaltum was dry, the plates were drawn on with an etching needle.

All 30 plates were bitten in a fast nitric acid (6 parts water to 1 part nitric acid) for about two hours. They were placed in a large acid tray in several layers, separated by small blocks of wood. Since this many zinc plates together in a fast acid created a great deal of heat, ice cubes were added from time to time to cool and dilute the acid. Altogether over a hundred pounds of ice cubes were used! The section comprising sky and clouds was completed with this one bite. The Volkswagen section required additional work. It was given a rosin-powder aquatint porous ground. The stripes on the figures and the area just below the sky were made by putting down masking tape to act as a stop-out while the plates were in the acid. This aquatint was bitten in the acid for approximately two hours.

The sky section was inked intaglio with Weber's colored etching inks, wiped with tarlatan, and finished off with a hand-wipe. The plates for the Volkswagen section were assembled and inked intaglio with Weber's Intense Black etching ink. The green and purple figure, and the space between the Volkswagen and the sky, were masked out with masking tape so they would not be inked. The plate was wiped with tarlatan and paper towels. All the colors in this section were rolled on in relief, using stencils and soft rubber brayers. The small white clouds inside the bus windows were bitten so deep that they could be cleaned out with a cotton swab if they collected either black ink or blue ink.

The etching was printed in 9 separate pieces and then trimmed and glued together. First the sky section was printed in 4 pieces. When the ink was dry, this section was trimmed, assembled, and glued together to make a flat print measuring 17 x 11 inches. Then the paper was creased, using a stencil-cutting tool, and folded to make 3 high-relief rectangles approximately 4 inches deep on the sky. The Volkswagen section was printed in 5 pieces and then trimmed and pasted together to make a flat print that measured 11 x 3 feet. Then the paper was folded into 3 high-relief rectangles to correspond to the 3 boxes in the sky. When both sections had been folded and placed together they measured 4 x 8 feet.

All 6 of the high-relief rectangles were supported from the back with cardboard boxes. The print was mounted on a piece of stiff cardboard and framed in a plexiglass frame. This etching was printed on Murillo paper in an edition of 5 in 1967.

4. The Collagraph Print

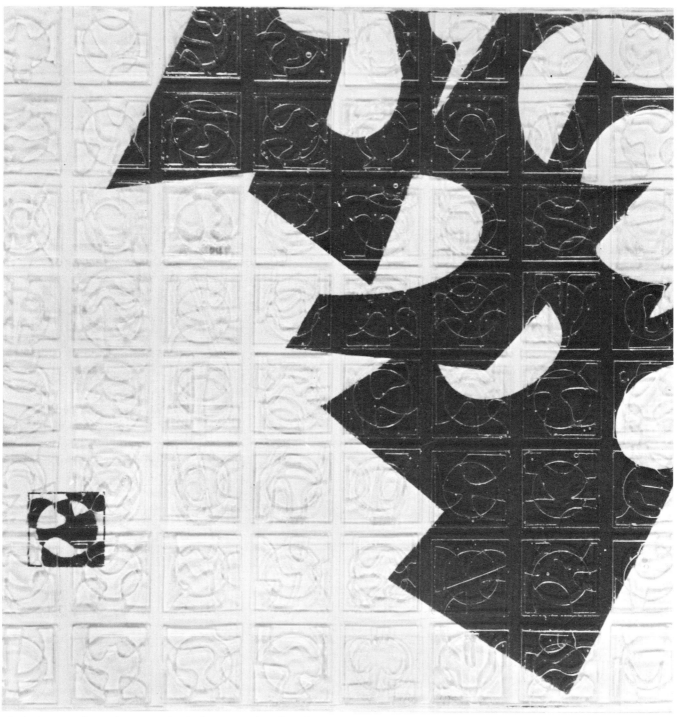

Black Shape, collagraph, 19½ x 19½ inches, 1969, by Glen Alps

Hula Hula, Masonite intaglio, 14 x 14 inches, by Edward Stasack

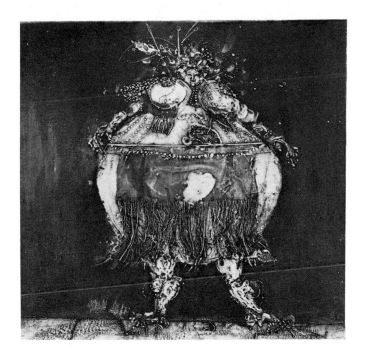

Arch, collagraph by Karl Kasten

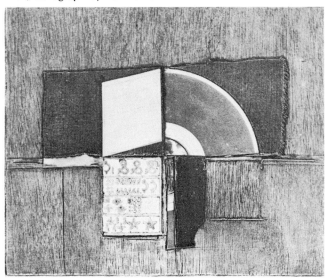

The *collagraph print*, or glue epoxy print refers to an etching plate made by adding materials to a plane surface that is ordinarily cardboard or Masonite, although it is sometimes metal. And ordinarily the material is glued on, although it can be soldered, nailed, or sewn, depending on the materials used. This method contrasts with all of the traditional etching techniques, in which metal is removed from a plate by the use of a burin, drypoint needle, acid, etc. The collagraph plate can be inked in either intaglio or relief or both at the same time.

The attraction of this technique for the etcher lies in the almost unlimited range of sizes, shapes, and surfaces that can be found—or made—and affixed to a plate. In this chapter some simple and well established methods and materials for making of collagraphs are described. The collagraph print is a highly versatile method for making a plate, and offers a variety of printing solutions: inking intaglio and/or relief, on- and off-press printing, paper and surfaces other than paper prints. The etcher should understand clearly that the opportunities to discover new materials and invent new methods are unlimited.

Making a Collagraph Plate

To make a collagraph plate, the etcher needs the following materials: (1) cardboard or ⅛-inch Masonite for the plate, (2) a variety of materials with varied surface textures, (3) glue, (4) acrylic modeling paste (or substitute), (5) brushing lacquer. The etcher first assembles materials for gluing, which might include canvas cloth, lace, string, nylon stockings, silk, aluminum foil, paper, sandpaper, acetate, coins, keys, metal pieces, wire screen, synthetic metals, natural materials such as leaves, modeling paste, automotive body filler, epoxy, underpainting white oil paint, and many other things. Next, he may modify the surface of these materials to affect the way they will print, by hammering, scratching, or polishing. Then he glues, embeds, or otherwise affixes the various pieces of material to the base. Acrylic paste (or substitute) can be used. The etcher spreads it on the

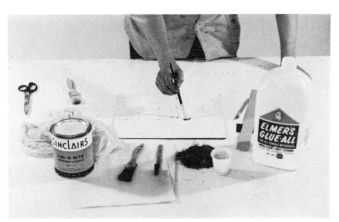

Gluing collage material on a Masonite plate

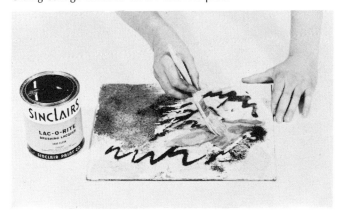

Brushing the resulting collagraph with lacquer to seal it

board with a palette knife, and, while the paste is still moist, scrapes, combs, presses, or scratches the surface, or embeds pieces of material in the paste. When dry, the paste can be sanded and polished. Finally, when all the surfaces of the collagraph have been prepared to the artist's satisfaction, he seals the plate by coating it with brushing lacquer to make it impervious to oil and water.

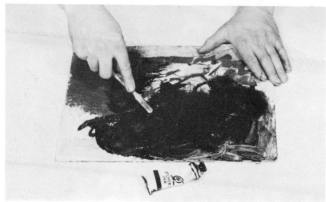

Next the collagraph is inked. The tool used here is a toothbrush, which can reach crevices in textured materials

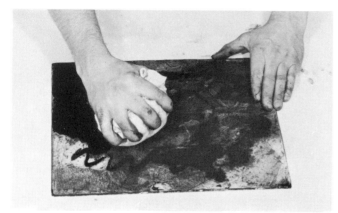

After intaglio inking, the collagraph is wiped with a rag

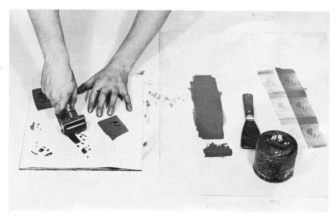

Then relief colors are rolled on with the aid of stencils and a soft rubber brayer

Pulling the collagraph proof

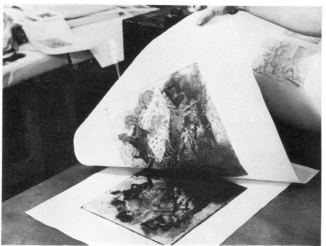

A plate made in this manner is sturdy enough to resist the pressure of the press, and is capable of producing an extended edition of prints, perhaps 20 to 25.

For satisfactory printing, there are some limitations that must be respected. The collagraph should be made of materials durable enough to produce a number of prints without deteriorating rapidly. No material should be attached to the plate that is so sharp that it will cut the paper. If the plate is to be printed in intaglio, the thickness of the materials must not vary too greatly, that is, the general level of the added materials must be approximately the same height as the surface of the plate. If one added surface is considerably higher than the others, then the paper, even under pressure, will not reach some of the inked areas. Working within these physical limitations, the etcher can choose those materials which most closely suit the needs of his design.

The etcher should remember that the intaglio-inked print will show a range of values and textures, while the relief-inked print will be black and white, and display only textural changes. On the intaglio plate smooth surfaces wipe cleaner, and therefore print lighter, and rough surfaces hold more ink, and therefore print darker. On the relief plate the higher surfaces, both rough and smooth, catch the ink, and the lower surfaces escape the roller, remaining white or uninked.

Collagraph: Metal Plate

The etcher can make a collagraph exclusively with metal if he chooses. First he finds a baseplate of a suitable material: iron, copper, brass, zinc, aluminium, etc. Then he collects metal materials: tin cans, wire, nails, keys, wire screen, bottle caps, metal filings, etc. There is, in fact, an endless variety of industrial metal products that can

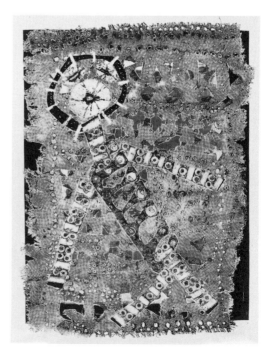

Figure on Green, metal print, 1964, by Rolf Nesch (Achenbach Foundation for Graphic Arts, California Palace of the Legion of Honor)

be used as is or hammered, forged, melted, bitten in acid. They are added to the base plate by a number of different methods, including soldering, welding, brazing, riveting, gluing, etc. The plate itself is a piece of low-relief sculpture, and it can be hammered, ground, filed, and polished until the design can be inked and printed to the etcher's satisfaction. Inking a plate like this is probably best accomplished by first inking it intaglio and then rolling additional colors in relief with the aid of stencils.

Collagraph: Cast Plate

The etcher-sculptor, at this point, seriously might consider casting an aluminum or bronze plate, by either the sand-casting or investment method. The original plate from which the cast is taken might be made out of either wax or Styrofoam (polystyrene).

To make a wax plate, the etcher pours a sheet of melted wax into a plaster tray, and then, using hot knives, torches, and various gouging tools, adds wax to wax according to the needs of his design. Using standard studio methods of casting, he invests and burns out the wax, and pours the metal.

The Styrofoam (polystyrene) plate is made using a flat sheet of Styrofoam as a base. Additional shapes of Styrofoam are glued onto complete the design. This plate is invested, and cast in the same manner as the wax plate. In preparation for printing, the artist can grind, scratch, or polish the cast plate to smooth it or add textures and lines. The cast-metal plate can be inked intaglio in the usual manner and printed like any collagraph plate.

Collagraph: Plaster Print, Resin, Latex

A "print" that is actually a plaster cast can be made of a collagraph plate provided there are no undercuts.

Latex print cast from resin mold

Resin print cast from flexible rubber mold

The collagraph plate is placed on a piece of glass, a wall of clay is built around it to act as a container, and plaster of Paris—mixed in the usual manner, by sifting plaster into water until distinct islands are formed, and then stirring with the hand for a few minutes until it begins to thicken—is poured over the collagraph plate to a thickness of approximately 2 or 3 inches. The plaster can be left white or it can be tinted with dry color or a water-base paint.

A resin print or plate can be made in a similar manner, by using casting resin instead of plaster. The resin is poured over the original collagraph plate (with no undercuts) that has first been coated with a release agent, such as green soap, so that the resin will not stick to the plate. This resin cast can be thin or thick depending on the needs of the artist. Casting resin comes in a wide range of colors, both translucent and opaque. A resin cast can be inked intaglio and used as a plate, as well as being used as a print.

A latex print can be made by painting or pouring latex over a collagraph original. When the latex has set, it is easily peeled from the plate. Since latex will pick up color, the collagraph original can be inked intaglio or relief, or both, resulting in a colored latex print.

Collagraph: Vacuum-form Print

A vacuum-formed acrylic print can be taken from a collagraph plate. Using a vacuum-form machine is simple: dials adjust the temperature of the heating elements to soften the plastic, and a button turns on the vacuum pressure, which molds the plastic around the collagraph. The operation takes only a few moments. Plastic will not pick up ink from the collagraph original, but the plastic itself can be bought white or colored, clear, translucent, or opaque. One suggestion for putting an image on the plastic sheet is to silk-screen it before the print is vacuum-formed. Another is to offset an image from an etching plate inked in relief. This is done with a gelatin brayer of large diameter (5 to 10 inches). The brayer is rolled over the relief-inked plate, and the offset image transferred to the plastic before it is vacuum-formed. After it has been vacuum-formed, the etcher can use the plastic print as a plate by gluing materials to the plastic that will hold ink and can be inked intaglio.

Pasadena Rose Bowl, photo-plate, aquatint, and viscosity print, by Leonard Edmondson

5. Viscosity Printing

Viscosity printing is another system of inking a plate in two or more colors and printing it by passing it only once through the rollers of the etching press. In this system, one color is rolled directly over another, but the different *viscosities* of the inks control the results. When a color of high viscosity, or "stiff" color, is rolled over a color of low viscosity, or an "oily" color, the oilier one has a tendency to repel the stiffer one. This allows the first color, the oily one, to remain pure while placing the second color, the stiff one, alongside it in a pure form. Conversely, when a stiff color is rolled on first and an oily color rolled over it, the two colors have a tendency to blend.

This unique method of color etching requires a special plate, accurate mixing of oil and pigments, and careful selection of rollers. Inking of the etching plate is primarily by an *offset* method: Color is first mixed and rolled out thin on a piece of plate glass, and then this color is picked up on a gelatin or soft-rubber roller and transferred to the prepared metal plate.

The viscosity method of applying color to a plate is distinct from other methods combining intaglio and relief because the etcher is using the interaction between colors of different viscosity to achieve his results. While he can use stencils, stencils are not essential to the effective preparation of this type of multicolor plate. Advanced plan-

ning based on the needs of the design and a knowledge of the process is essential for an effective print. The plate itself must be prepared so that it presents three or more clearly differentiated levels. The color scheme must be planned in advance, because the final results depend on the selection of colors and the careful preparation of their relative viscosities, as well as the sequence of their application, which determines whether the colors are to be pure or blended.

In addition, viscosity printing is a refinement of offset printing because the selection of rollers accomplishes the color intention of the etcher, which is determined by the relative softness or hardness of the rollers and the sequence in which they are used. The rollers should be of sufficient diameter that the ink can be applied with one pass of the roller. The rewards of this method are the diversified color effects that can be accomplished by combining both pure and blended colors on a plate, and the ease of rolling the paper through the press only once, which avoids the problems of accurate registration.

This account of a special technique of color application is intended to give a basic understanding of the process. The etcher should experiment with materials and processes until he has solved the problems of color to his own satisfaction.

Making the Plate

The etcher must first make a metal plate that has at least three clearly differentiated levels: a top level that is the original plate left untouched by the acid, a second level that is somewhat lower, and a third, lowest level. This three-step plate makes it possible, using rollers of different penetration, to produce complex structures of color without the use of stencils.

According to the needs of the design, the etcher stops out those portions of the plate where the first color is to be relief rolled. Then he places the plate in nitric acid and lets it bite for twenty minutes or more if using the recommended one-to-five solution or until the entire plate, with the exception of those areas originally stopped out, is bitten down perceptibly. Then the etcher stops out additional areas on the plate where he wishes the second color to be relief rolled and returns the plate to the acid tray to continue the biting action for another period of time, approximately 20 minutes, sufficient to produce a second distinct layer. When the plate is removed from the acid and the stopping-out varnish removed with solvent, the plate is ready to ink.

Some etchers prefer to aquatint the lowest layer of the plate since this is the layer that is inked intaglio. The other two layers, which have been prepared for relief inking, are left untextured. The top layer, which has been protected, is the original surface of the plate, the second layer is a smooth open-plate bite.

Tsunami, color intaglio and viscosity print by Joan Binkoff

Poet in Void, color viscosity print, 23 x 40 inches, by Bob Evermon

Poissons Volants, three-color viscosity print, 1958, S. W. Hayter (La Tortue Galerie, Santa Monica)

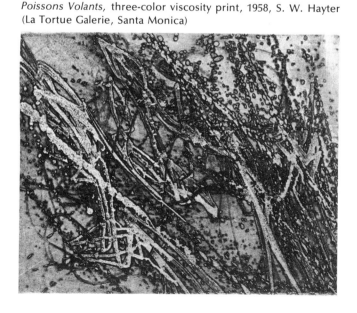

Inking the Plate

First the etcher inks the plate in intaglio with black or colored, viscous ink. In principle, the intaglio color will be wiped off the first and second levels, and will remain on the lowest level. If the lowest level has been aquatinted, it will, of course, hold more ink. Next, the etcher prepares two additional colors. One of the colors is mixed with raw linseed oil to make it less viscous than the other. The oiliest color is deposited on the highest level of the plate with a hard rubber roller. The etcher's intention is to lay a coat of color only on the highest level of the plate, without reaching the second level. The second color, of higher viscosity than the preceding one, is rolled on both the highest level and the second level of the plate with a soft gelatin roller. The less viscous color that was laid down first repels this second, more viscous color rolled over it. At this stage, the plate is inked in three colors, one in intaglio and two in relief, and is ready to be printed in one roll through the press. The resulting print will show two pure relief colors and a third intaglio color.

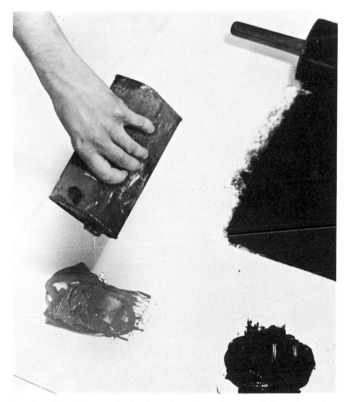

In the viscosity method, the viscosity of one of the pigments is changed by the addition of oil. Here stand oil (treated linseed oil) is being poured

Bacchanal, collagraph and viscosity print, 15 x 20 inches, by Martin Mondrus

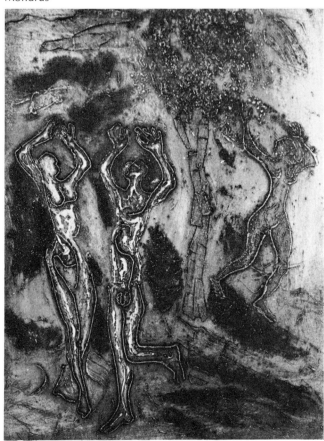

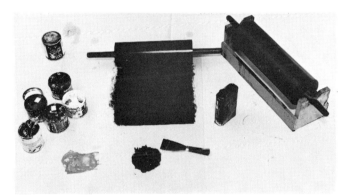

Next, two different types of rollers are used to deposit the different viscosity pigments on separate levels of the etched plate

Viscosity inking in relief an already intaglio-wiped plate. A very large roller is used so that there is no danger of over-roll

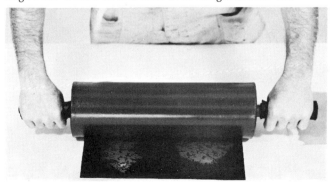

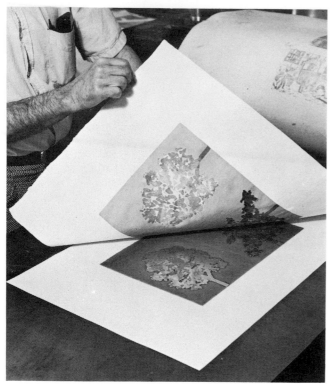

Pulling the proof. Since the plate has been inked in three colors —one intaglio and two in relief—only one roll through the press produces a three-color print

Color Variations

Three basic variations in the viscosity method should be explored by the etcher. Even though he uses the same plate and the same three colors in the identical sequence, he can achieve three different color effects. The plate is prepared as described before so that it has three distinct levels: top surface, middle level, lowest level. The three colors that will be used in this demonstration are: first, intaglio-wiped black ink, second, rolled-on blue ink, and third, rolled-on yellow ink.

Variation 1

To begin the first variation, ink the plate intaglio, using black ink; next, roll blue on the top surface of the plate, using a hard roller and a color mixed with raw linseed oil to make it low in viscosity; finally, roll on yellow ink mixed to a viscosity equal to or less than the intaglio black and greater than the blue color. This yellow color is rolled over the blue with a soft gelatin roller and sufficient pressure to reach the middle level of the plate. The result will be pure yellow, blue, and black on the different levels.

Variation 2

For the second variation ink the plate in intaglio with black as before, then roll on a blue of high viscosity with a hard roller. The hard roller lays color only on the highest level of the plate. Next, apply a lower-viscosity yellow with a soft roller. In this variation the more viscous color is laid on first. The oilier color is laid on top of it on the highest level, and at the same time reaches the second level in a pure state. The result is a blended color, green, resulting from yellow over blue on the highest level, and a pure yellow color on the second level. The green and the yellow appear on the print in relation to the intaglio-inked black from the lowest level.

Variation 3

In the third variation, begin again by wiping the plate intaglio with black ink. Then roll on a blue of high viscosity with a soft roller that reaches both the top level and the middle level. Follow this with a yellow mixed to a lower viscosity and applied with a hard roller that reaches only the highest level. As a result, the higher-viscosity blue will accept the lower-viscosity yellow, making one blended color (green) on the top level, and leaving one pure color (blue) on the middle level. The intaglio color will print black.

6. Photographic Methods

Photographic methods in etching should be among every etcher's techniques. They provide a way for him to discover new images and new textures. I will briefly describe some of the many photographic methods available to the etcher with the anticipation that each etcher will discover new methods to produce the kind of print that is personally most expressive.

Collaboration with the Commercial Photo-engraver. The etcher who wishes to use photographic techniques should learn from the beginning that commercial engravers can offer invaluable assistance. They have excellent equipment, are experts in the field of photographic reproduction, and are often very willing to cooperate with etchers. They can provide technical assistance when the etcher does not have his own photographic equipment and supplies. When collaborating with a commercial engraver, it is the etcher's responsibility to provide the negative transparencies and to direct the engraver concerning enlargement, reduction, cropping, choice of halftone screen, degree of contrast or tonal gradation, etc.

Sometimes, in order to prepare his negative for the engraver, the etcher must have several different negatives of the proper size so that he can crop and assemble a composite photo-negative. The engraver transfers any negative brought to him by the etcher to a metal plate, then bites the plate in acid, and returns the plate to the etcher—ready to ink and print. Ordinarily the engraver's plate prints positive when rolled in relief. Therefore the etcher should be cautioned that if he wants to print his plate in intaglio and have a positive print, he must ask the engraver to use a black-and-white positive transparency. This can be made from a negative transparency with Kodalith film and a contact camera.

Stereotype Photo-plate

The easiest plate for the etcher to employ, since it involves no preparation on his part, is the used and discarded photo-plate made by the commercial engraver-printer. This metal plate, which is cast from a papier-mache, plastic, or rubber mold, and is used in commercial printing, is called a *stereotype plate*. It can be inked and

Self-Portrait, photo-etching and collagraph
by Corwin Clairmont

Papier-mache mold (left) and stereotype photoplate (right). The easiest way for the etcher to take advantage of commercial printing equipment is by using already-prepared plates

printed by the etcher in his studio exactly as he would print a plate of his own making—that is, either intaglio or relief. Ordinarily the stereotype plate prints positive when it is rolled in relief and negative when it is wiped intaglio. The etcher has the choice of using this plate alone, or, as is usually the case, in combination with other plates and etching techniques that he has learned.

Offset Photo-transfer

Another, indirect way to use the commercial engraver's stereotype plate is to make an offset transfer of it. First the stereotype plate is rolled in relief using etcher's ink or soft-ground paste. Then the design is transferred to a gelatin or soft rubber roller large enough in diameter to take the whole design on one roll, without overlapping. The image on the roller is then offset onto a new copper or zinc plate. The etcher's ink or soft-ground paste will act as an acid-resist when the plate is put in a tray of nitric or ferric acid. The etcher can combine the offset image on the new plate with other etching techniques such as etched line, aquatint, or soft ground.

Another way for the etcher to make an offset plate is to ink the original stereotype plate, either in intaglio or relief, with etching ink or soft-ground paste, and then take a print of it on dampened paper in the usual way. Then, before it has time to dry, he lays this freshly printed paper face down on a new copper or zinc plate and runs it through the press under slightly reduced pressure. The image is thus offset from the paper to the plate, and the ink or the soft-ground paste will act as resist when the plate is placed in acid. Again, the etcher can modify this offset image by combining it with other etching techniques. The advantage of the offset technique is that it is relatively simple and easy.

Papier-mâché mold

If the etcher has a commercially made papier-mache mold in his possession he can employ it to make an etching plate by the application of the soft-ground method. First, he lays a coat of soft ground on his plate. Next he places the papier-mache mold on the plate and runs it through the etching press, adjusting the pressure carefully so that

the press is not too tight. When the papier-mache mold is removed, the metal will be exposed so that it will be bitten by the acid. This plate can be inked either intaglio or relief. Again, it is clear that the etcher has the freedom to modify the soft-ground image or to combine the commercially made image with other techniques.

Studio Photographic Techniques

Whenever possible, the etcher should use methods with which he can be directly involved in the studio or workshop. In this way, he not only acquires new technical skills but also can supervise each critical step in the technical development of his art. The basic photographic needs are: a dark room, a copy room, a vacuum frame, an arc lamp, a light-sensitive plate, developing fluid, and halftone dot screens, Nos. 65 to 120. With such basic equipment, etching plates can be prepared by methods elementary enough to be performed in the artist's own studio or workshop.

The two basic methods for transferring a photo image to a plate are the halftone method and the hand photogravure method. This description deliberately simplifies the processes so that the etcher, out of his own curiosity and invention, will combine techniques in his own way to find substitute materials and methods. The field of photography in combination with etching is open and fluid, and there is much to be learned and much to be discovered. The etcher is encouraged to read further and to continue to explore in the studio, especially all methods that deal with exposure and development time, where each etcher must experiment until he finds optimum technical solutions.

Sky, Plane, Water, photo-plate etching, by Leonard Edmondson

As many people are aware from their own observations, all magazine and newspaper photographs, whether in black-and-white or color, get their range of values from a dot pattern. Where the dots are small and far apart, the values are light; where the dots are large and close together, the values are darker. These mechanical dots are made by a halftone screen. These screens can be purchased in a range from Nos. 65 to 150. The smaller the number, the larger the dots are. If the etcher prepares a transparency from a commercial photograph that has already been screened, he will not need to add another screen.

Light Sensitive Plates. Commercially prepared light-sensitive zinc plates can be bought from a store that supplies photoengraving materials. The manufacturers of prepared plates specify the kind of developing fluid needed and provide directions for its use. If the etcher wishes to make a light-sensitive plate in his studio, he can buy a light-sensitive gelatin emulsion coating and apply it to a regular zinc plate as follows. He begins by cleaning the zinc plate with ammonia and talc, and then he washes it in clear water. The plate is not allowed to dry (the water prevents oxidation) until the light-sensitive coating has been applied. The coating is prepared by mixing a liquid gelatin emulsion with a light-sensitive material (directions are on the product) and applying it to a plate taped down to a spinner. The spinner is set for 80-100 RPM, and, as the plate spins, water is poured over it to prevent corrosion

and act as a vehicle to spread the light-sensitive emulsion. Then the coating is poured evenly and slowly onto the center of the plate until enough has been applied to cover the entire surface. The top of the spinner is closed and the plate spun for 15 minutes under infra-red light until the topping is dry. The plate is now ready to be exposed and developed.

Preparing the Black-and-White Negative Transparency. The copy, a photograph or a magazine picture (either black-and-white or color), is placed on the copy board. The copy is reduced or enlarged to the appropriate size and focused. The aperture is adjusted to f16. In the darkroom under safelight, Kodalith Ortho film is placed light-side-out on a vacuum back and covered with a halftone screen, emulsion-side-in. If a magazine or newspaper photograph is being used, no halftone screen is necessary because one has been used to make the original plate. The vacuum back is shut, and then the film is exposed for 1 unit, approximately 70 seconds, on the timer. After the vacuum back is opened, the film is exposed to a 13-second flash, using an amber Kodak safelight filter OA with a 25-watt bulb.

Developing the Black-and-White Negative Transparency. The transparency is developed in a tray of equal parts A and B Kodalith developer for 2 minutes and 45 seconds. It is then washed in water and put into the fix for 5 to 10 minutes or until it is clear.

Transparencies and halftone screen. In the studio the etcher can combine a transparency with a dot pattern to produce tones like those used in commercial printing

The Magic House of the Heart's Desire, intaglio etching and photo-engraved assemblage, by Kenneth A. Kerslake

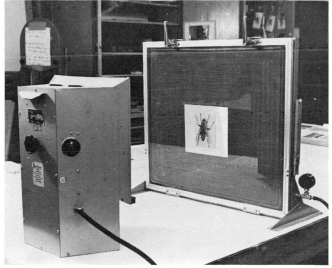

To do this, he must expose a light-sensitive plate to an arc lamp (at left). The transparency and the plate are tilted vertically in the frame of a vacuum table (at right)

Finally the plate is developed according to the directions supplied by the photo-plate manufacturer (or, if the etcher has chosen to coat his own plate, according to the directions of the manufacturer of the light-sensitive coating)

Exposing the Light-Sensitive Plate to the Kodalith Halftone Transparency. The photo-sensitive plate is placed in the vacuum table and the black-and-white Kodalith Ortho halftone transparency is placed over the plate. The door to the table is closed, the vacuum turned on, and the vacuum table is tilted up. An arc lamp approximately 3 feet from the window of the vacuum frame is used to expose the plate for 4½ to 5 minutes. The plate is developed according to directions supplied by the manufacturer of the light-sensitive coating. Usually this involves a development period of several minutes, then a wash in water to remove the developer, and finally heating the plate on the stove or burner until the light-sensitive gelatin coating still on the plate is hardened enough to resist the action of the mordant for the necessary time. During development the etcher should be able to see the image developed on the plate in some detail. The exposed areas will be bitten in the acid, the areas still covered by the light-sensitive, acid-resistant coat will be protected.

Etching the Plate. The photo-plate can be etched in ferric chloride or nitric acid. Ferric chloride bites more slowly and more accurately, and does not undercut like nitric acid. When a halftone screen is used, the etcher will observe that wherever the plate has been bitten by the acid, a distinct, mechanical dot pattern is incised in the metal. This dot pattern, which holds ink the way a coarse aquatint does, is particularly important if the plate is prepared to be inked in relief.

Biting the photo-plate in nitric acid is critical. A plate that is intended to be inked in relief is bitten differently than one prepared to be inked intaglio. Members of the Pioneer Press Club have perfected the following method, which preserves the halftone dot structure and produces excellent prints.

Prepare a nitric acid solution of 1 part (by volume) nitric acid added to 6 parts (by volume) of water. To etch a plate that is to be inked in the relief method, leave the plate in the nitric acid 10 to 15 minutes, agitating the acid constantly with cheesecloth or a feather. This produces a relatively deeply bitten plate with enough space between the dots so they will not run together. To etch a plate that is to be inked intaglio, the biting time is shorter. Place the plate in the acid bath for 3 to 4 minutes, agitating the acid constantly with cheesecloth or a feather. Then take the plate out, dry it with paper towels, and give it a light coat of white spray lacquer. Bite the plate in nitric acid for another 2 minutes. Remove it from the acid, add another coat of white spray lacquer, and return it to the acid for 2 minutes. After this bite, carefully wash off the white spray lacquer with denatured alcohol or shellac thinner (being careful not to rub too hard, which disturbs the protective coat of acid-resistant material still left on the plate), spray once more with white lacquer, and return the plate to the acid for 2 minutes. Repeat the spraying, and return the plate to the nitric acid for the final 2 minutes.

Altogether the plate has been in the acid for approximately 11 minutes. Wash off the lacquer again with paint thinner or alcohol without disturbing the acid-resistant coat, since this coat makes the plate easier to wipe. The result is usually a finer, less-mechanical aquatint tone than obtained by the halftone screen method.

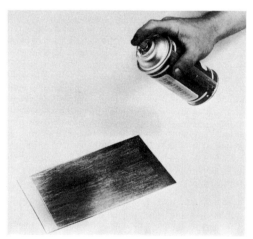

Instead of using the somewhat mechanical halftone screen to produce an aquatint effect, a lacquer aquatint can be sprayed on a photo-plate

Biting the photo-plate in acid while agitating it with cheesecloth

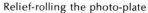

Relief-rolling the photo-plate

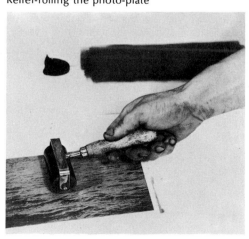

Taking a proof of the photo-plate

90

The photogravure plate is an intaglio plate. The image is etched into the metal and sunk below the surface. The negative used is a continuous-tone, positive transparency. The metal is usually copper. To shape the spaces, or wells, that are bitten into the copper and hold the ink, a line screen is used. Kodak Magenta Contact screen for photogravure is available in three rulings: 120-, 133-, and 150-lines per inch. What is actually exposed is a thin film made in three layers: (1) a gelatin emulsion layer that takes a photographic image, hardens in proportion to the light that strikes it, and resists the action of the ferric acid, (2) a stripping membrane which serves as a waterproof protective layer, and (3) a film-base support. Dupont Cronar Rotofilm or Kodalith Ortho film, type 3, (Estar Base) can be used for this support. It is recommended that the film be handled under red Wratten 1A safelight with a 15-watt bulb at a distance of 4 feet.

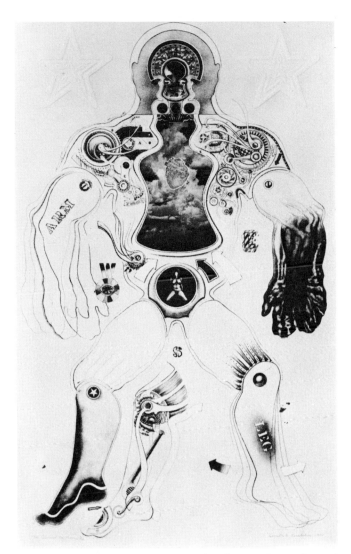

The Switched-On Man, engraving, airbrush, aquatint, embossed and photoengraved assemblage, 27 x 42 inches, by Kenneth A. Kerslake

Procedure for Exposing the Film. The film is placed in a vacuum frame or on a vacuum board, emulsion-side-up, and a magenta contact screen, face (dull)-side-down, is placed over the film. Then the film is exposed briefly, from 10 to 20 seconds, to a yellow light that sets the pattern of the screen on the film. The continuous-tone positive is next placed over both the Rotofilm and the screen, and a second exposure with yellow light is made, which controls the size of the "dots." The magenta contact screen is removed, and a third exposure is made through the continuous-tone positive with ultra-violet light. This exposure controls the depth to which the "dots", or wells, will be etched.

Procedure for Processing the Film. These procedures vary somewhat depending on whether the film used is Dupont Cronar Rotofilm or Kodak Kodalith Ortho Film, Type 3 (Estar Base). First the film is developed in Solution A, then drained, developed in Solution B, and rinsed in water. Finally the film is fixed, washed in two rinses, and dried.

After the film has been exposed and developed the etcher adheres it to the copper plate by wetting the plate with water and laying the film, emulsion-side-down, on the plate. The film-base support is removed immediately after the film has been adhered. Next, the membrane is removed by pouring diacetone alcohol over the film so that the resists are made wet quickly and uniformly. After this solvent treatment, hot water should be applied promptly, using a spray system so that all traces of the membrane are immediately carried away. The gelatin is then developed in hot water for a few minutes, using a continuous overflow or spray system to remove the unhardened parts of the gelatin coating. Then the film is cooled in water. The plate is etched in a solution of ferric chloride. The mordant penetrates to the metal surface in proportion to the thickness of the gelatin. As a result, the plate is etched to depths corresponding to the tones of the original image.

More detailed directions can be found in other sources such as the booklet, "How to use the Kodak Magenta Contact Screen for Photogravure" published by the Eastman

Wiping the Photo-Plate. Both the relief and the intaglio plate should be wiped with tarlatan, paper towels, newsprint, and finally chalk dust or talc in a hand-wiping.

Hand Photogravure

Another method of transferring a photographic image to a plate is called *hand photogravure.* This is a continuous-tone process as opposed to other photographic processes that use only black and white, no gray, to achieve the effect of continuous tones. The photogravure method is based on two facts: (1) that a film of light-sensitive gelatin will harden when exposed to light, becoming hardest when exposed the longest to the most intense light, and becoming only slightly hard to the degree that the light is blocked, and (2) that an aqueous solution of ferric chloride will attack the softest parts of the gelatin first and the harder parts later.

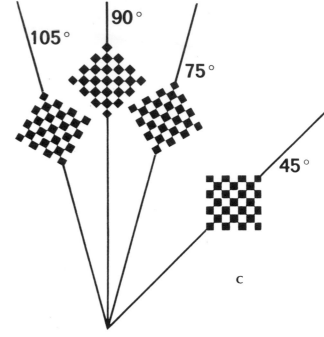

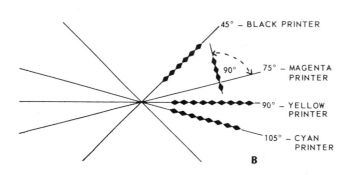

SCREEN ANGLES

Yellow, magenta, and cyan Kodalith color printers are made with screens that are cut with a template at specified angles in relation to the dot chains in the screens. (A) Cutting a contact screen with a template. (B) Direction of the dot chain in the contact screen in relation to the conventional angles. (C) Diagrammatic representation of the screen angles. (Diagrams A and B, Kodak Graphic Arts Data Book Q-3, "Halftone Methods for the Graphic Arts"; photo C, Dupont Photo Product brochure, "The Contact Screen Story")

Kodak Company or the booklet on Cronar Rotofilm published by Dupont Photo Products Department.

The advantage of hand photogravure for the etcher is that the process can achieve a more satisfactory range of values than the somewhat mechanical halftone method. Color prints can also be made by hand photogravure by the color separation method described in this chapter.

Photo-plate Color Separation

Among the many color methods available to the etcher, color separation is proving to be of great interest. It is primarily a commercial process, and the majority of color pictures in contemporary magazines and books are printed by this method of offset lithography. Although space does not permit a detailed description of the complicated four-color process, the following schematic procedure may clarify the basics and suggest ways that color separation can be used by the etcher in his studio with a minimum of equipment and with methods probably already familiar to him.

Color separation is a photo-plate method that requires a darkroom, a copy camera, a vacuum frame, an arc lamp, and three color filters: red, green, and blue. Recommended filters are Kodak Wratten Gelatin filters: No. 58, No. 25A, and No. 47B. Color separation achieves natural-looking color by combining only four colors—black, yellow, magenta, and cyan. Each color is printed from a separated plate.

The basic procedure consists of positioning the copy (usually a color photographic print) on the copy board with the proper focus with the halftone screen, inserting the proper color filter over the camera lens, positioning a special film into the camera back along with the halftone screen, making an exposure at a setting determined by the filter factor, making a supplementary flash exposure, and removing the film and developing it. This step-by-step procedure is followed four separate times to make the film for the one black and the three color plates. The figures given are for a 100 per cent (double size) enlargement.

For the black separation: position the copy on the copy board at a 45-degree angle in relation to the halftone

screen, set aperture at f16, position Kodalith (Ortho) film and No. 65 or finer halftone screen into camera back, *shoot without any filter* at exposure of filter factor 1 (70 seconds) with 13-second flash. Then develop the film for 2 minutes and 45 seconds with AB Kodalith developer.

For the yellow separation: position copy on copyboard at 90-degree angle in relation to halftone screen, set aperture at f16, position Kodalith (Ortho) film and No. 65 halftone screen into camera back, *shoot with the blue filter* at an exposure of filter factor 25 (multiply filter factor times base factor, equals 1,750 seconds or 29 minutes) with 13-second flash. Then develop the film for 2 minutes and 45 seconds with the AB Kodalith developer.

For the magenta separation: position copy on copy board at 75-degree angle in relation to halftone screen, set aperture at f16, position Kodalith (Ortho) film and No. 65 halftone screen into camera back, *shoot with the green filter* at an exposure of filter factor 3 (multiply filter factor times base factor, equals 210 seconds or 3½ minutes) with 13-second flash. Then develop the film for 2 minutes and 45 seconds with AB Kodalith developer.

For the cyan separation: position copy on copyboard at 105 degrees angle in relation to the halftone screen, set aperture at f32, position Pan film and No. 65 halftone screen into the camera back, *shoot with the red filter* at exposure of filter factor 3 (multiply filter factor times base factor, equals 210 seconds or 3½ minutes) with *no flash.* Then develop the film for 2 minutes and 45 seconds with AB Kodak developer for Pan film. (Pan film should be handled and developed in total darkness.)

The negatives made by this method are negative film transparencies. When the photo-sensitive plates are exposed to these transparencies and developed, the results are plates that must be bitten in nitrid acid for 10 to 15 minutes, and prepared by inking in the relief method with soft rubber brayers. Intaglio inking may also be done, but since commercial color separations are printed from relief-inked plates, a multiple-plate etching made with relief inking will more closely approximate natural color.

Equally interesting results may be achieved by inking color-separation plates intaglio. When this is done, the etcher can make a color positive transparency by using a contact camera. Kodalith film is placed in the vacuum table, white-side-up, the negative transparency, emulsion-side-down, is placed on top of the Kodalith film, the contact camera switch is turned on, and the film is exposed for approximately 3 seconds. Then the film is developed for 2 minutes and 45 seconds in AB Kodalith developer. The result is a reverse copy of a negative transparency, which is a *positive* transparency.

Nonphotographic Negatives

In all the studio photographic methods for etchers, plates must be prepared by transferring an image to the surface of the metal before biting in acid. The image may be on photographic film or it may be derived in other ways. For example, the etcher can use one of his own drawings as a transparency. To do this he must draw on

Mirn, photo-plate and viscosity color etching, 17 x 22 inches, by Clinton Cline (Photo by Malcolm Varon)

a surface that will allow light to penetrate, such as tracing paper, clear acetate, frosted acetate, etc. The etcher can make the drawing with pen and ink, brush and ink, lithographic pencil, graphite pencil, etc. The drawing is exposed on the light-sensitive plate in exactly the same way as a photographic transparency would be. He may use a halftone screen to produce an aquatint or grain the plate later with a porous ground, using a spray-can of white lacquer. The plate may be bitten in nitric acid or ferric chloride.

Photostencil Screen Printing

Another way to make a photographic plate is to use a silk-screen to transfer a photostencil to a metal plate. There are two basic ways of preparing a screen photographically: (1) the direct way, in which the screen is coated with a liquid emulsion that has been made light-sensitive, and (2) the transfer method, which involves the use of a sensitized film tissue that has been made to adhere to the screen. In both methods a positive (an opaque image of the design, on a transparent surface) is an essential element in producing the *photostencil*. The positive is prepared either by hand, like a drawing, or by using a camera.

Photostencil: Direct Method. The direct method calls for coating the screen with a liquid photographic gelatin emulsion. This can be done by applying two coats with a rubber scraper under subdued illumination. Then the light-sensitive screen is placed in a vacuum frame and the handmade or photographic positive transparency is placed over the screen. If desired, a halftone screen can be added. The screen is now ready to be exposed to the light. After it has been exposed, it is washed out in warm water. As the unexposed areas of the emulsion wash away, the photostencil image on the screen appears. To transfer the photostencil image to a metal plate, the etcher places the screen over the plate and an acid-resistant paste ground is squeezed with the rubber scraper through the screen and onto the plate. Sometimes an oil-based screen paint is acid-resistant enough for this purpose. When the image has been transferred to the plate, the plate is ready to be bitten in ferric or nitric acid.

Photostencil: Transfer Method. In the transfer method, the photo-emulsion, in the form of a specially prepared film, is exposed and developed before it is placed in contact with the screen. The film used in the transfer consists of a clear sheet of gelatin, or emulsion, supported on a clear polyester backing. The etcher cuts it to size, places it in the vacuum frame, and covers it with the positive. A halftone screen is added if a mechanical dot tone is desired. After the screen has been exposed, developed, and washed out, it is transferred to the plate, and from here on the etcher uses the same procedure as in the direct method.

A slight modification of the photostencil method is to use a normal screen, which is not light-sensitive, and to prepare it for printing in the traditional screen printing method, with glue and tusche or stencils. Ink is screened through onto a transparent material such as clear acetate or tracing paper, which then can be used as a substitute for a photographic transparency.

Magazine Transfer Transparency

The etcher can make a transparency by transferring the ink from a magazine picture to tracing paper. He applies a solvent such as lighter fluid, benzine, acetone, lacquer, silk-screen clear base such as Naz-Dar, paint thinner, etc. to the back of the magazine picture, lays the picture face down on the tracing paper, and rubs the back of the picture with a burnishing tool or a cardboard scraper. In a few moments the ink from the magazine picture will have been transferred to the tracing paper. Sometimes, particularly with Naz-Dar clear base, the ink can be transferred by running the magazine picture and tracing paper through the press under severe pressure. If enough ink is transferred onto it, the tracing paper can act as a transparency.

The etcher can make a transparency in another fashion by transferring a magazine picture to a sheet of clear adhesive acetate. The magazine picture is laid face down on

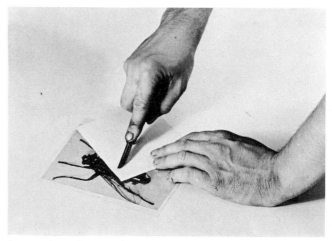

A magazine photograph can be used as a transparency if it is first transferred to adhesive acetate

Next, the magazine picture and adhesive acetate are soaked

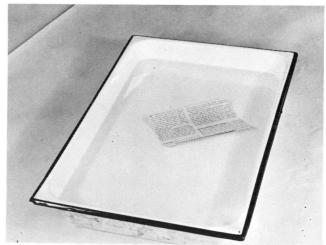

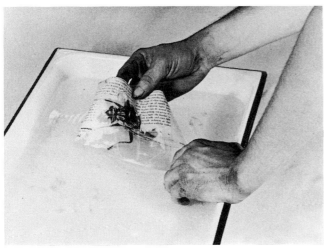

Then the acetate is peeled away from the magazine paper

And the acetate can be used as a transparency. Since all magazine pictures have halftone dot patterns, it is not necessary to add an additional screen

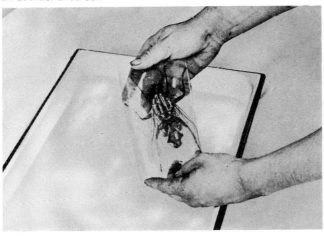

Homage to Burroughs–Flight, etching and photo-plate, 24 x 36 inches, 1969-70, by Robert A. Nelson

the sticky side of the acetate, and then it is rubbed with a burnisher or run through the press under severe pressure. Next, the etcher places the acetate with the magazine picture adhering to it into a pan of warm soapy water and lets it soak until the paper can be pulled off or rubbed off the acetate. The image from the magazine picture will be transferred to the adhesive acetate, and the acetate can be used as a transparency. The ink that has been transferred to the acetate is thin and delicate, and care must be taken not to scratch it. Since all magazine pictures already have a halftone-screen dot pattern, it is not necessary to add an additional screen. However, a lacquer spray-ground aquatint may be added to reinforce the halftone aquatint, particularly if the plate is left in the acid for more than 10 or 15 minutes. This transparency is exposed and bitten in the manner previously described.

The etcher working in his studio or workshop may discover that a good deal of trial and error is necessary before this process gives satisfactory results. When the methods of intaglio, stencil, and relief inking are combined, complex color relationships can be achieved with only two or three plates.

Handmade Color Separations

If the etcher chooses to use his own drawing as a substitute for a photographic transparency, he can draw his own color separations on separate sheets of clear acetate or tracing paper. Each of these handmade color separations can be exposed on a different light-sensitive etching plate. Each plate can be inked in its own color and the plates can be printed in a sequence one over the other. This technique does not require any color-filter technology.

With the rapid advance in photographic technology, new materials and new processes for making photographic plates are constantly becoming available. Simple methods for doing color separation in the etcher's studio will soon be in common use. Each etcher should take the opportunity to inform himself about photographic supplies and techniques and, by experimentation, to modify them or combine them with other etching techniques to achieve the most satisfying artistic results. The use of the photographic plate in etching expands the etcher's range of images and textures; it can be manipulated by the etcher in many ways to fit his creative needs.

The Big Red Eclipse, cardboard, intaglio, and assembled-plate print, 40 x 30¼ inches, 1971, Gabor Peterdi (Grace Borgenicht Gallery, New York)

7. Multimedia Printmaking

Multimedia printmaking encompasses many combinations of printmaking techniques, including etching combined with other media such as woodcutting, screen-printing, and lithography. Each of these four basic printmaking media is produced by an essentially different method. *Etching* is essentially an intaglio method, which has already been described in detail. *Woodcutting* is a relief method in both inking and printing. Ink is applied only to the top surface of the block, usually with a roller, so that chiselled out surfaces receive no ink at all. *Screen-printing* is a stencil method. The parts of the screen not intended to print are blocked out with glue or paper. *Lithography* is a planographic (surface-printing) method. In surface-printing the part that is to be printed is on the same level as the part that is not to be printed, and the separation is based on the mutual antagonism between grease and water.

While the woodcut, silkscreen, and lithograph printing are different from one another in materials, technique, and visual effect, all three share certain characteristics. Each can be printed on paper suitable for an intaglio print. Each is capable of a broad range of shapes, lines, textures, and both flat and modulated areas. Necessarily, each method produces certain visual effects unique to itself.

The woodcut line is typically thick, and ranges from smooth to ragged. The marks of the knife and the gouge are easily discerned, and a natural woodgrain texture from the plank is often visible. The silk-screen is very easy to prepare and very versatile. The range of lines (from pen lines to brush lines) and textures is extensive. When several screens are used, the overlapping transparent colors can produce exceptional hues. The lithographic print can have a crayon-drawing quality or a wash-drawing quality, depending on the materials used, with both flat and subtly modeled color areas. Pencil-drawing, pen-drawing, and brush-drawing qualities are easily produced, and the range of textures is unlimited.

Blending two or more printmaking methods into a single print can produce unique qualities not attainable through the use of any one method used singly; most particularly it can increase the color range and surface variation of color printmaking. Since each printmaking medium is capable of creating a variety of visual qualities, the selection of the appropriate medium to use in combination with the etching will rest with the sensitivity of the printmaker and the needs of the imagery. In all cases of multimedia prints, the intaglio plate is printed last so that the embossment is not flattened out. The etcher should exercise some

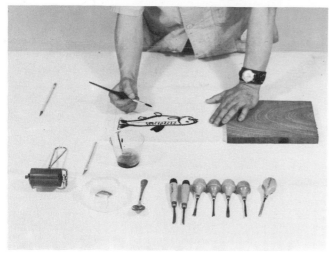

Preparing the drawing for a woodblock. Gouges, spoon, brayer, and other necessary equipment are shown

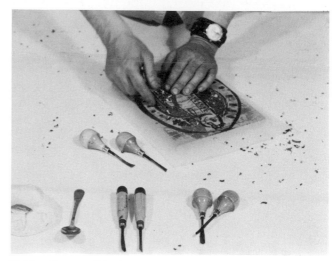

Cutting the woodblock

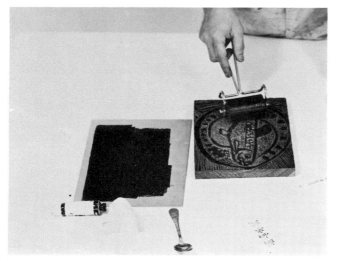

Inking the woodblock with a brayer

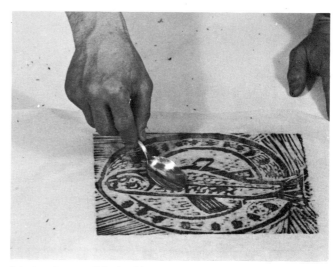

Printing the woodblock with a spoon. The image of the fish shows through the paper—the inked side is face down

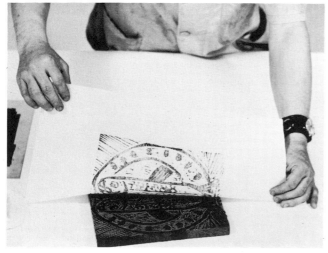

Lifting the print

caution to see that the combination of several prints in different media add up to a balanced effect so that one print does not obscure another. The descriptions of print-making techniques that follow are not intended to be exhaustive treatments but to stimulate etchers to learn more on their own. Knowledge of the relief method, the stencil method, and the planographic method will serve the intaglio printmaker to better realize his expressive and artistic goals.

The Relief Print

In relief printing, the artist first cuts away everything that is to remain white, and then uses a roller to deposit ink on the parts that have not been cut away. Many different materials can be used to make a relief print: wood, Masonite, wallboard, plywood, linoleum, cardboard, etc. Many different tools can be used to cut the material: knife, razor blade, gouge, motor drill, machine sander, band

saw, jigsaw, etc. I will describe in detail the preparation of a wood block and many of the materials, tools, and techniques discussed can be adapted to other relief prints.

In addition to the block of wood itself, the basic supplies needed to make a woodcut are a knife, a gouge, a soft rubber roller and some block-printing ink. Any *plank wood,* that is, wood sawn parallel to the grain, can be utilized. The woodcut maker will select a particular plank for his particular design—soft or firm, straight-grained or knotty. Many woodcut makers have expressed a preference for the wood from fruit trees like apple, pear, and cherry. Any knife that has a strong sharp blade can be used to cut away the wood. Often gouges, both V-shaped and U-shaped, are employed to supplement the knife blade. Before cutting into the wood, the printmaker usually stains or paints the surface so he can sketch on the wood with pencil, crayon, or ink, but he may paste a drawing directly on the plank. All parts of the design to remain white (areas not intended to print) are cut away from the plank of wood to the approximate depth of ⅛ to ¼ inch, depending on the size of the block and the complexity of the design. A depth of ⅛ inch may be sufficient for a small, complex block. If several colors are required, a separate block may be cut for each, or, if the color areas are far enough apart from one another to permit a controlled rolling, any number of colors may be rolled on a single block.

In relief printing, color is rolled onto the block with a soft rubber brayer, which must be the appropriate length and diameter for a particular block so that no color is laid into the cut-away areas. Many different oil-base colors can be used: block-printing ink, printer's ink, lithographic ink, oil paint, etc. The printmaker rolls the color thin on a piece of glass, and then rolls the brayer over the wood block. He must be careful to apply only a thin coat of color, and to apply it only to the highest surface of the wood.

When the block has been rolled up with color, the print-maker lays a piece of paper on it. No matter what kind of paper—many varieties may be used, including etching paper—it must be large enough to leave an ample margin around the wood block. The paper is usually printed dry, although it may be printed damp in order to pick up ink more evenly.

Printing can be carried out by hand or with the aid of a press. There are presses made specially for wood blocks, but an etching press or a lithography press will serve as well. For hand printing, the printmaker simply rubs the back of the paper with a spoon (rounded side toward the paper) or a burnisher. The printmaker must press the paper firmly against the wood and rub it firmly and thoroughly in several directions.

If a press is chosen, the printmaker must use one in which the pressure is not too great for the delicate wood block. The character of the resulting print and the extent of the edition also will be affected by the type of press used. The image will be darker but blurry with heavy pressure and more precise but faint with lighter pressure. A press that exerts great force will wear the block down more quickly, and the edition will be accordingly limited. One of the reasons for using a wood block press, which works on the principle of a nutcracker—pressure being applied by physical force through the leverage of a long handle—is that its pressure is light, and therefore large, accurate editions can be made on it. Because a wood block press exerts greatest pressure at the center and increasingly lighter pressure at the edges only small blocks can be printed on it.

In an etching press, the wood block is printed under rollers, like a metal plate, but instead of blankets a piece of stiff cardboard is laid over the block and paper. On a lithographic press, the action of a scraper bar, passing over the *tympan,* which is a metal sheet placed between the paper and the scraper bar, will transfer ink from wood to paper, just as it does from stone.

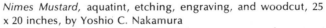

Nimes Mustard, aquatint, etching, engraving, and woodcut, 25 x 20 inches, by Yoshio C. Nakamura

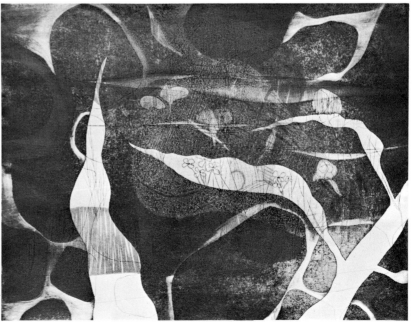

The Screen Print

Screen-printing is a stencil method based on the fact that ink can be squeezed through a porous fabric onto paper or cloth. The materials required for screen-printing are: a wooden frame, a porous fabric, blocking-out material, a *squeegee*, a scraping tool made with a rubber or flexible plastic blade mounted in a wooden handle, colored ink, and transparent base. To prepare a screen the printmaker stretches a woven, mesh material on the frame, and tacks or staples it in place. Traditionally this porous fabric has been silk, but nylon, Dacron, and other synthetic fibers, as well as finely woven metal fabrics made of stainless steel or copper can be used interchangeably with silk. The wooden frame is hinged to a table or a piece of plywood with loose pin hinges so that the printing frame can be removed and cleaned when necessary. To facilitate cleaning, the wooden frame and a margin on the screen are covered with butcher's tape and sealed with a coat of brushing lacquer.

Drawing on a silk-screen with glue. The blocked-out areas will not print

Quo Vadis, mixed media, 33½ x 23 inches, 1971, Lettorio Calapai

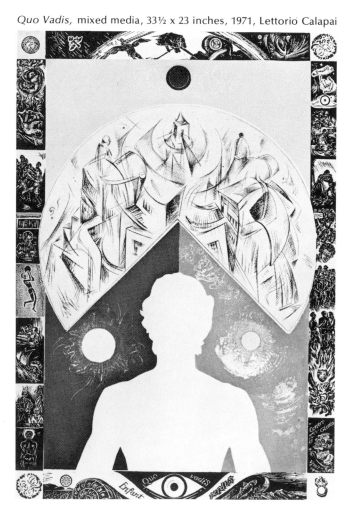

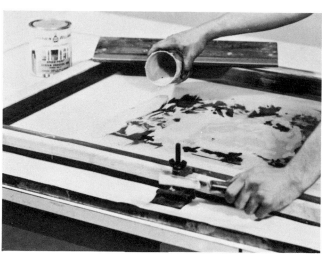

Pouring ink on the silk-screen

Printing the screen with a squeegee, which pushes the ink through the unblocked areas of the screen

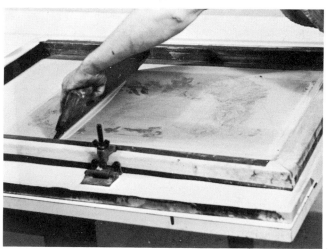

Block-out and Wash-out Methods

There are two traditional methods of preparing the screen: covering the stencil (blocking it out) and washing out the blocked areas of the stencil. The covering stencil can be made by blocking out the areas not to be printed with either glue or paper.

The glue recipe is equal parts Le Page's glue and water, mixed to a brushing consistency. The glue is brushed on or scraped on with a piece of cardboard, and when it dries it becomes a water-soluble resist for oil-base colors. Wherever glue has been applied, paint cannot be squeezed through the screen onto the paper.

To prepare the stencil by blocking out the screen with paper, the printmaker can use any relatively thin paper: newsprint, typing bond, etc. Pieces of paper, cut with scissors or torn, block those parts of the design not to be printed. When all the pieces are laid underneath the screen, paint is drawn over the screen with a squeegee. The paint itself makes the paper adhere to the screen so that a number of prints can be made with the identical blocked-out pattern.

Another common block-out material is *film stencil,* a transparent laminated film composed of a layer of lacquer on a backing sheet. The printmaker cuts the design in the film stencil, using a stencil knife and pressing lightly enough to cut through the lacquer layer without penetrating the backing sheet. The cut areas, which are stripped away, print on the screen. The screen is first laid over the film stencil (lacquer-side-up), making a firm contact. Then the film stencil is adhered to the screen with a special adhering fluid as follows. The printmaker applies the liquid to the screen, with a small, damp cloth, covering a small section at a time. He immediately dries each area by rubbing it briskly with a dry cloth. This wetting and drying process is continued until the entire stencil adheres, and then the backing sheet is removed. Any additional areas on the screen that still need to be blocked out can be covered with glue or lacquer, applied with a piece of cardboard.

The wash-out stencil is prepared with tusche and glue. First, the areas of the design that are to be printed are painted on the screen in lithographic tusche with a water-color brush. Note that in the block-out methods it is the areas *not* to be printed that are painted. After the design is filled in with tusche, a coat of glue is spread over the entire screen, design and all, with a cardboard scraper, and the glue is allowed to dry. The tusche is then dissolved with paint thinner, a solvent that does not affect glue, and wiped away with a rag or paper towels. The result is that the screen is open only where the tusche was originally painted.

Photographic Stencil Methods

There are two basic methods of preparing screens with photographic stencils: the direct method in which the screen is coated with a liquid emulsion that has been made light-sensitive; and the indirect, transfer method involving the use of a sensitized film tissue that adheres to the screen. In both methods the photosensitive surface is placed in the vacuum frame, covered with a photo-negative, and exposed to the arc light. In the direct method the photosensitive screen can be washed out in warm water immediately after it has been exposed to light. In the transfer method the presensitized film must be developed, with the developing solution furnished by the manufacturer, before it can be washed out in warm water and adhered to the screen. Further details about photographic stencil methods in etching are given in Chapter 6.

Printing the Screen Print

The basic procedure for printing is the same, no matter how the screen has been prepared. First, all the paper to be printed in the edition is cut to the identical size. Tabs are set on the table, under the hinged screen, to hold each piece of paper in identical registration. Then the oil-base screen color is prepared, using equal parts pigment and transparent base. As the proportion of transparent base is increased, the color becomes increasingly transparent.

The printmaker adds a generous amount of paint at one end of the frame and squeegees it the length of the screen in one continuous motion. The squeegee should be slightly narrower than the frame so it can slide easily. This squeegee action presses the paint through the mesh of the fabric onto the paper. The screen frame is lifted, the printed paper removed and replaced by a new piece, and then the screen is lowered on the paper and the squeegee operation repeated. When the last piece of paper has been printed, the screen is cleaned of paint with paint thinner, rags, and paper towels. The resist material on the screen mesh also can be cleaned away to make the screen fabric ready to be used again for another design.

When used in conjunction with an etching plate, the screen can be printed on paper, as described above, and then this print can be dampened and overprinted with an intaglio plate on an etching press. Or the design on the screen can be printed as a relief stencil directly on a metal plate that has already been inked intaglio. In this method the plate has to be rolled only once through the press to achieve a multicolor print. The advantages of the screen method over the etching-stencil method is that it offers much more variety and freedom, since the screen can print fine lines, textures, brush-stroke effects, while the etching-stencil method can only print broad, flat areas of color.

The Lithographic Print

Lithography is a planographic process: lithographs are made by printing from a plane surface. On the principle that grease and water do not mix, the design is drawn on the stone with a greasy substance that attracts ink and, at the same time, repels water. The area not intended to print is treated so that it attracts water and repels ink. The equipment and materials for lithography include: a lithographic press, lithographic stones and/or plates, carborundum, gum arabic, and nitric acid.

The lithographer can draw his design on either a stone or a metal plate. The stone is usually finely porous lime-

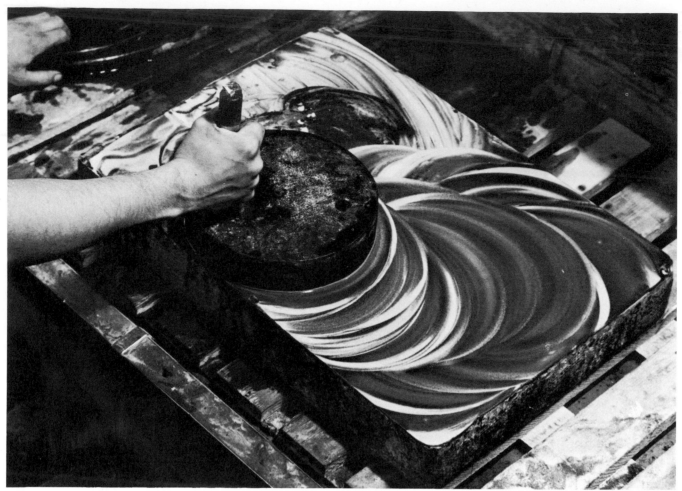

Graining à lithographic stone with a levigator

stone; the plate is usually either aluminum or zinc. The principle difference in working with a plate rather than a stone lies in the etching—etching the stone produces a physical as well as a chemical change while the change in a plate is only chemical. The etch for a plate is more precise, and the acid content of the gum arabic solution must be measured accurately. Since lithography is described here only as an adjunct of intaglio printmaking, only the more common methods of working on a stone will be discussed.

Grinding the Lithographic Stone

The printmaker selects a lithographic stone, and proceeds to grind off the old image, or *grain*, the surface to a smooth, even texture. He wets the stone with water, sprinkling it liberally with No. 80 carborundum, and grinds either with another, smaller stone laid on top of the lithographic stone or a *levigator*, a special steel disk made for this purpose. The general motion of graining should be circular or, if another stone is used, a figure 8 may be described. After a few minutes of grinding, the old image will entirely disappear. At this point, the carborundum

powder is washed off with water and a finer-grain carborundum, No. 150, is sprinkled on the stone. Again, the stone is grained for a few minutes until the surface texture is smooth and even. If a still finer grain is required, the lithographer can wash off the No. 150 carborundum and grind the stone for a few minutes with No. 220 carborundum.

Drawing on the Lithographic Stone

The drawing is made on the stone with a greasy substance, such as litho pencil, litho crayon, tusche, lithographic drawing ink, liquid asphaltum, oil-base ink or color, etc. Usually the lithographer allows a one- or two-inch margin on the stone. In addition to drawing, the surface of the stone can be painted on, spattered, offset on, transferred on, scratched, rubbed, scraped, burnt with acid, or textured in other ways. For example, a knife, a pointed rod of abrasive material, a hard ink eraser, and many other improvised tools each can produce special results. The lithographer makes his individual discoveries by practice and experiment.

Some lithographers prefer to draw on tracing paper or

specially coated transfer papers instead of directly on the stone. This method is called *transfer lithography*. The drawing, made with a greasy material, is transferred from the paper to the stone by placing the paper, drawing-side-down, on the grained lithographic stone, and running the stone several times through the lithographic press.

Preparing the Lithographic Stone

When the drawing has been completed, the stone is prepared for printing. First, the lithographer dusts it with powdered rosin, which he rubs gently over the drawing. Then he brushes it off and replaces it with talcum powder, which in turn is rubbed over the drawing and lightly brushed off.

Next, the stone is etched with a solution of gum arabic and nitric acid. The proportions of this solution will vary according to the value contrasts of the drawing and the room temperature. An average solution would be approximately 30 drops of nitric acid (using an eye dropper) in 1 ounce of gum arabic. The etching solution must be strong enough to effervesce slightly on the stone. It is applied liberally all over the stone with a brush, a sponge, or by hand. After two or three minutes the excess gum should be blotted from the stone and the remainder of the gum rubbed down thin and fine with the palm of the hand or a piece of cheesecloth. The purpose of the etch is to desensitize the stone, making it incapable of further grease absorption, while at the same time making the crayon drawing more grease-attracting.

Drawing on the stone with a litho pencil

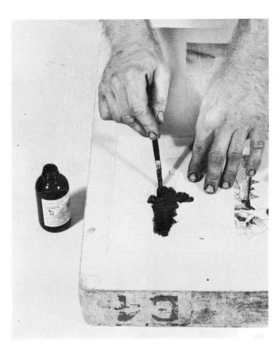

Drawing on the stone through a stencil with liquid tusche

After the drawing has been made, rosin and talc are applied to prepare the stone for printing

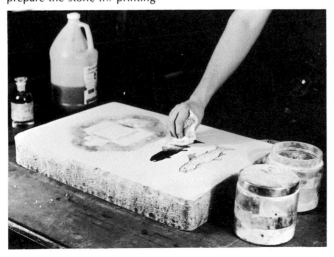

Next, the stone is etched with a solution of gum arabic and nitric acid

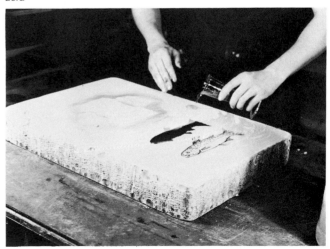

Many lithographers recommend that this etch be left on the stone overnight, while others agree that the print-maker can proceed when the gum is dry. In either case, the crayon or tusche drawing is then removed by washing it out with paint thinner, turpentine, or Lithotine, while the coat of gum is still on the stone. When the drawing has been removed, the entire stone is washed clean with cold water, which removes the gum and floats off all the loose particles of tusche and crayon. The stone is now ready to be rolled up using lithographic printer's ink and a leather roller; a gelatin roller is used for colored ink. The printmaker must keep the stone damp by sponging it with cold water until he is ready to charge the open areas with ink.

Proving the Stone and Printing

Proving the stone is the act of charging it with ink. After the stone is charged with ink it is printed on a lithographic press, which differs from an etching press in that the pressure is delivered by a bar that "scrapes" the stone and its various coverings, rather than by rollers. The stone must be wider than the scraper bar, because otherwise the edges of the stone make gouges in the scraper bar, and must be placed so that the bar passes over the entire design.

The lithographer prepares his special ink by working it up on an old stone or glass palette with a spatula until it is soft enough to drip off the spatula. Ink is transferred, lightly and evenly, from this palette to the stone with a

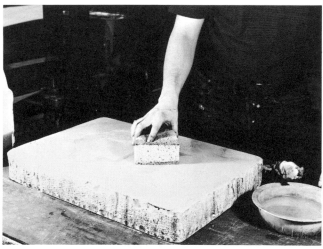

Then the drawing is removed by washing the stone with paint thinner, turpentine, or lithotine. The entire stone is washed with cold water

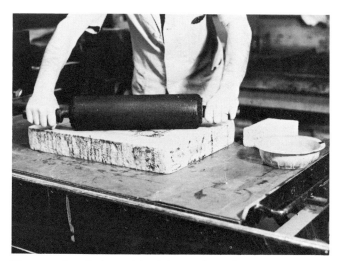

The stone is rolled up with a lithographic roller

Printing the stone on a lithographic press. Notice the metal tympan and the scraper bar, features different from the roller system of an etching press

Pulling the proof

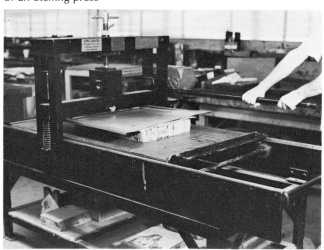

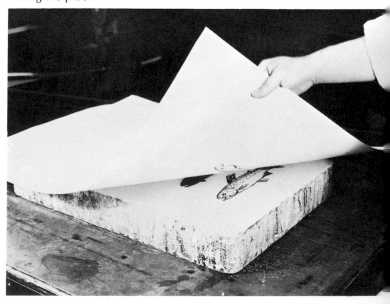

Target and Reflection, etching and lithograph, 23 x 18 inches, by William Ritchie

lithographic roller, until the image begins to appear on the stone. During the entire proving operation, and later during the printing, the stone must be kept damp. As long as the stone is damp, the desensitized areas will not accept ink, while the drawing continues to repel water and readily accept the ink.

Before printing the edition, the lithographer takes one or several proofs on a piece of proofing paper, usually newsprint, until the image on the stone is sufficiently inked. Minor corrections can be made during printing by cleaning spots on the stone with dilute nitric acid and a snakeslip stone, which is a white, spongy material used as a substitute for the natural abrasive, cuttle bone.

During printing, the lithographic stone is covered with printing paper that can be either wet or dry, depending on which picks up ink from the stone most effectively. On top of the paper go two regular clean blotters for cushioning, a tympan board, which takes the direct pressure of the scraper bar, and must be very well greased with a lubricant such as ball-bearing grease. Next, the pressure of the scraper bar is adjusted to accommodate the stone, and, when all is ready, the press lever is pulled down. The stone is cranked through the press, the press lever is released, and the tympan, blotters, and print removed. The stone is redampened immediately, before another piece of paper is run through the press.

EXPERIMENTAL TECHNIQUES

I propose two directions that etching must take in order to continue to be of service to artists. The technical boundaries must be continuously expanded, and etching must become part of an intermedia experience. The following chapters contain suggestions for experimentation in materials and techniques that will lead to a redefinition of the boundaries of the craft of etching. Some of these experiments already have been tried successfully by etchers, while others are still in the research stage.

There is a Time, kinetic print and intaglio etching, 24 x 20 inches,
by Michael Ponce de Leon (Photo by Arthur Swoger)

8. New Materials and Processes

New directions in etching will come about as a result of a careful examination of the materials, equipment, and processes that the etcher uses, with a clear intention to alter them to meet new artistic and technological demands. The most basic variables that can be altered are the plate, the surface on which the image is printed, and the method of printing. Although some variations have been discussed in the preceding chapters, they have been within the limits of traditional etching.

The Plate

The first thing to examine is the plate itself. By definition, the plate is the surface that is inked so that a print may be taken from it. We have already spoken of plates made of iron, copper, zinc, Masonite, and cardboard, but a plate can be made of any material that is stiff enough to hold its shape and strong enough to resist the pressure of the press without crushing or crumbling. For example, cellocuts are prints made from plastic plates. Basically, a plate can be made by the subtractive method, additive method, or a combination of both. Incising with a hand tool, biting in acid, or burning with an acetylene torch are examples of subtracting material from a plate. Gluing and soldering are examples of adding material. However, the surfaces of a plate can be made as a unit by casting, in such materials as fiber glass and epoxy, casting resin, flexible resin, plastic, synthetic metals, aluminum, bronze, etc. Each of these materials requires special techniques; some plates can be hand-formed while others need to be poured in a mold.

Life Field I, color intaglio on galvanized iron plate and copper plate, 22 x 28 inches, by Keith Achepohl

From Meteorites, cellocut by Boris Margo (Achenbach Foundation
for Graphic Arts, California Palace of the Legion of Honor)

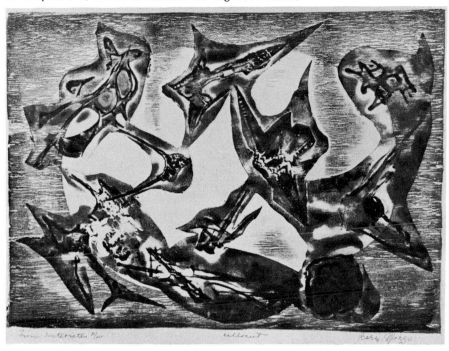

Winter, drypoint and drill point, 20 x 16 inches (platemark), 1963,
Peter Takal (Photo by John D. Schiff)

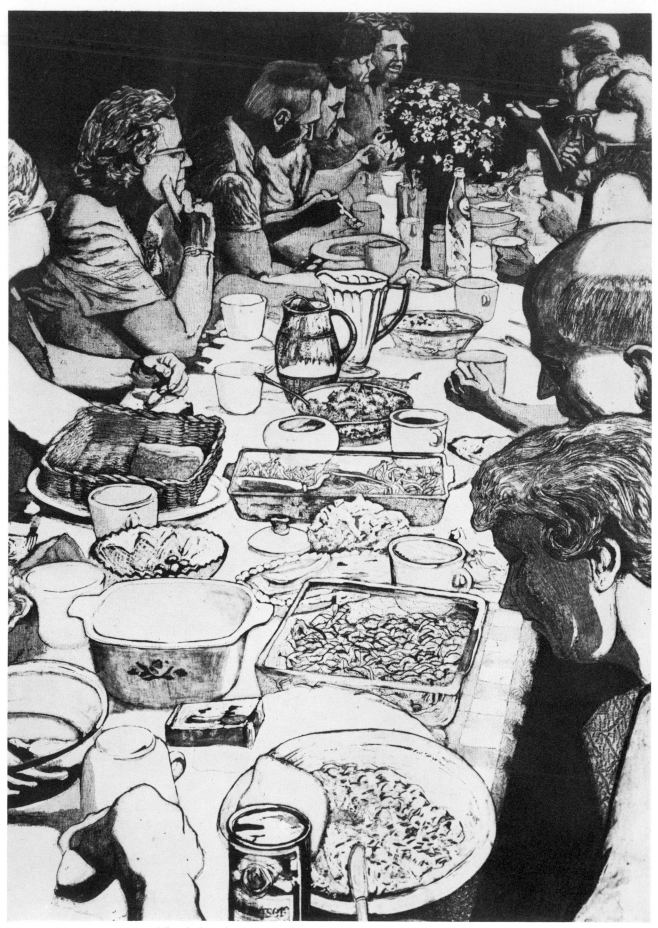

Picnic, etching, engraving, and flexshaft tool, 34 x 21 inches, by Daniel L. Ziembo

Untitled, inkless intaglio and embossment by Jean-Etienne Legros (San Francisco Museum of Art)

The Printing Surface

The etching plate can be printed on any surface that can be embossed and that will take color, although prints are sometimes left uninked and show only the natural surface of the material. In the past the traditional printing surface for etchings has been paper, but in these days of technological invention and discovery there is a wide range of synthetic fibers to print on. The printing surface can be any color or value, can be either coarse or fine in texture, and can be either soft or hard. A list of plentiful and easily available substitutes for paper might include: cloth, leather, aluminum foil, Naugahyde, Corfam, latex, flexible resin, plaster, Styrofoam, silicone—other synthetic materials on which the etcher can print are constantly appearing on the market. Some have properties similar to paper: they are manufactured in sheets, can be printed damp, and can be rolled through the etching press. Other products may be printed dry, may require a brushed or sprayed surface coat before they will pick up ink, or may come in a liquid or paste form and therefore be printed by pouring, painting, or spraying the plate rather than passing it through the etching press. Printing on surfaces other than paper will not only change the look of etching, it will also allow larger etchings to be printed.

Printing the Plate

In the light of new materials for plates and surfaces, the equipment traditionally used for printing the plate, in both on-press and off-press systems, can be re-evaluated.

On-press printing starts with the traditional etching press, in which the bed of the press is cranked, under pressure, between rollers. But, with a little imagination, it is easy to identify other, equally effective, systems. Commercial printers use the letterpress, the offset press, and the photogravure press. A very workable press that etchers can use in the studio is a hydraulic press. This prints with vertical instead of horizontal pressure—that is, the pressure is applied on a plane rather than a line. It is particularly effective for deeply embossed prints since it accurately registers and prints positive and negative plates together. Because the hydraulic press prints under intense pressure like the roller press, the plates themselves must be made of a sturdy material that will withstand pressure well enough to print an edition before breaking down.

Another vertical-pressure machine capable of printing an intaglio plate is a stamping machine. Again, as in the hydraulic press, the intense pressure used calls for a plate that is strong enough to resist the crushing action of the impact. The stamping machine opens the door to printing on such intractable surfaces as metal, as well as printing from deeply embossed plates that are either inked or uninked. For a deeply embossed inked plate, the choice of printing surface and the preparation of a cushion of felts are critical.

The vacuum-form press provides a solution for printing on plastic, with either an inked or an uninked print. The original plate from which the vacuum print is taken is usually some variation of a collagraph built up in high enough relief to emboss the plastic sheet into a low-relief sculptural print. Techniques for making collagraphs are described in Chapter 4. The vacuum-form press has a heating element that softens the plastic and a vacuum chamber that allows the softened plastic to mold itself over any form that is placed in the chamber.

Plastic comes in a wide variety of colors, and ranges from clear to translucent to opaque. Experimental etchers are working to determine what coloring materials and systems are most effective for transferring color from the collagraph plate to the plastic print. Some excellent prints have been made by silk-screening an image on the unformed, flat plastic with coloring material that is not damaged by heat, and then molding the plastic after it has been colored. Instead of silk-screening, it is equally easy to transfer an offset image to the flat plastic with a soft gelatin roller before placing it in the vacuum chamber.

There are many off-press printing methods, only some of which require pressure. Pressure can be applied in a variety of ways without using a press. Heavy rollers, such as lawn rollers or truck wheels, or heavy weights can be used. Especially for intaglio printing, an adequate cushion of felts must be provided. If the etcher has made both a positive and a negative plate, then the print can be taken using relatively less pressure since the positive plate fits directly into the negative plate, and no blankets are needed to transfer the pressure.

Here is a suggestion for an internal pressure system. Use an expandable material, like Styrofoam or polyurethane, which can be poured into a mold in a liquid state and that expands as it hardens in the mold. If the mold has been inked before the liquid printing surface is poured, the pressure of the physical expansion of the material as it hardens should be enough to make an intaglio print. Industrial technology has many such synthetic products that can be used by the printmaker seeking new methods and materials.

Systems of printing that do not require any pressure can also be explored. "Cast printing" would involve surfaces that can be poured, painted, or sprayed on a mold and pick up ink merely from the contact with the inked surface of the mold. Some of these materials, like latex, can be left as thin as paper; others, like flexible resin, can be poured thick. Etchings printed in this fashion would ordinarily be made from a clay, plaster, fiberglass, or plastic mold rather than from a metal plate. Some casting materials may have to be baked or heat-treated until they are cured and tough enough to handle and others will dry at room temperature. Depending on the properties of the printing surface, the coloring material might be an oil-base, acrylic-base, polyester-base, or rubber-base ink or paint. The mold can be inked in intaglio or relief, or both, and then the printing surface put in the mold without pressure. When the print is lifted away from the mold, the ink has been transferred to the surface. If the material is soft and the print deeply embossed, the print may have to be stuffed to retain its shape. Much experimentation needs to be done to find new materials and to improve techniques for cast printing, but the technique offers a remarkable range for exploration, and leads the printmaker into sculptural-print solutions.

The materials and technical solutions suggested here for alternative on-press and off-press printing systems must be constantly challenged and expanded by the etcher. These suggestions are meant to be guide lines toward experimentation. The attempt is to focus the attention of the etcher on matters of materials and processes so that his curiosity and inventiveness will be aroused.

Untitled, color etching by Enrico Baj
(San Francisco Museum of Art)

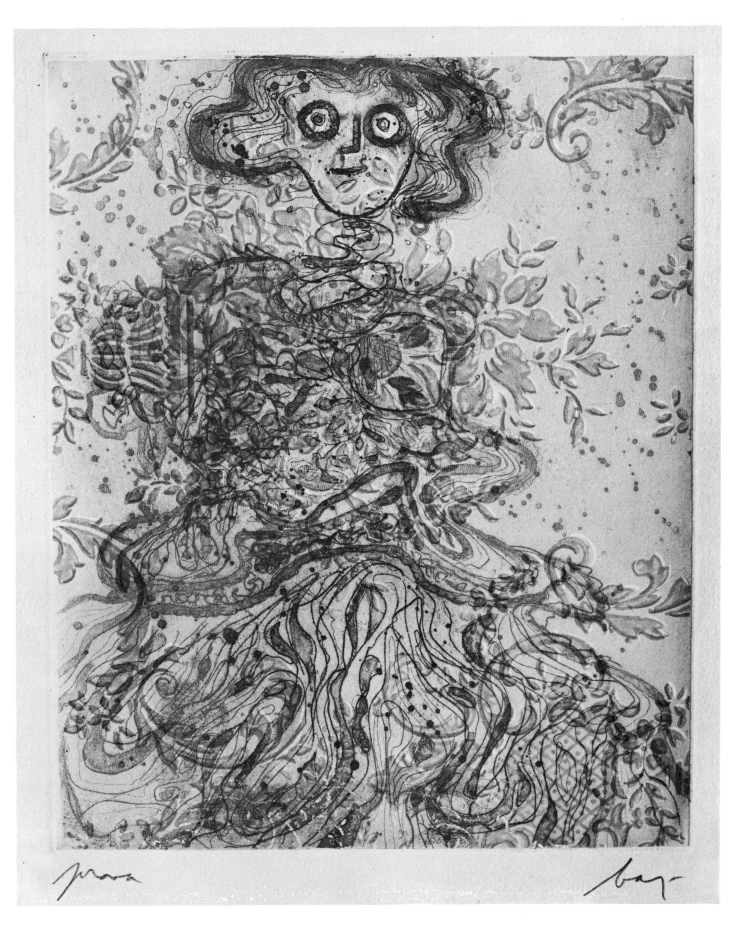

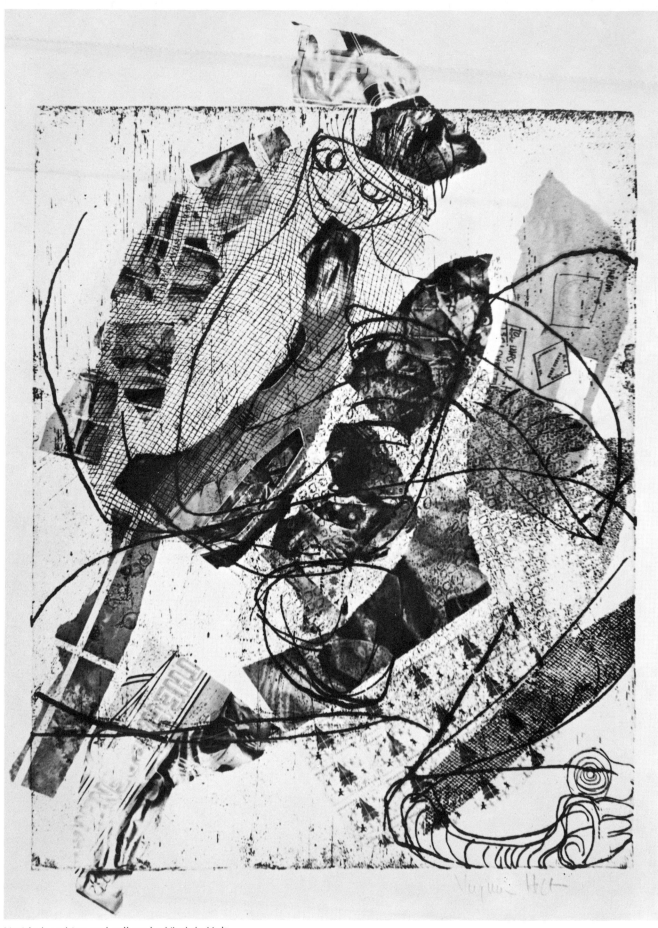

Untitled, etching and collage by Virginia Holt

9. Collages, Decals, and Other Transfers

In the search for new imagery, etchers are turning to the ready-made printed material of the commercial printing presses. Two readily available sources are decals and magazine pictures, both of which have been printed in such a way that the ink can be transferred to another surface, if desired. However, the easiest way to incorporate commercial printing into a handmade etching is to use it in a collage. The etcher cuts out a magazine or newspaper picture and pastes it on the etching paper. Then he overprints it with a regular metal plate inked in intaglio or relief. This collage technique allows the etcher to introduce color easily into the work with only one printing. Some care must be taken in the selection of a glue that is not water-soluble, since the paper must be dampened before printing, and the magazine paper may wrinkle and eventually fade. The possibilities of combining commercial and handmade printing in the collage technique allows for an increased range in the juxtaposition of images.

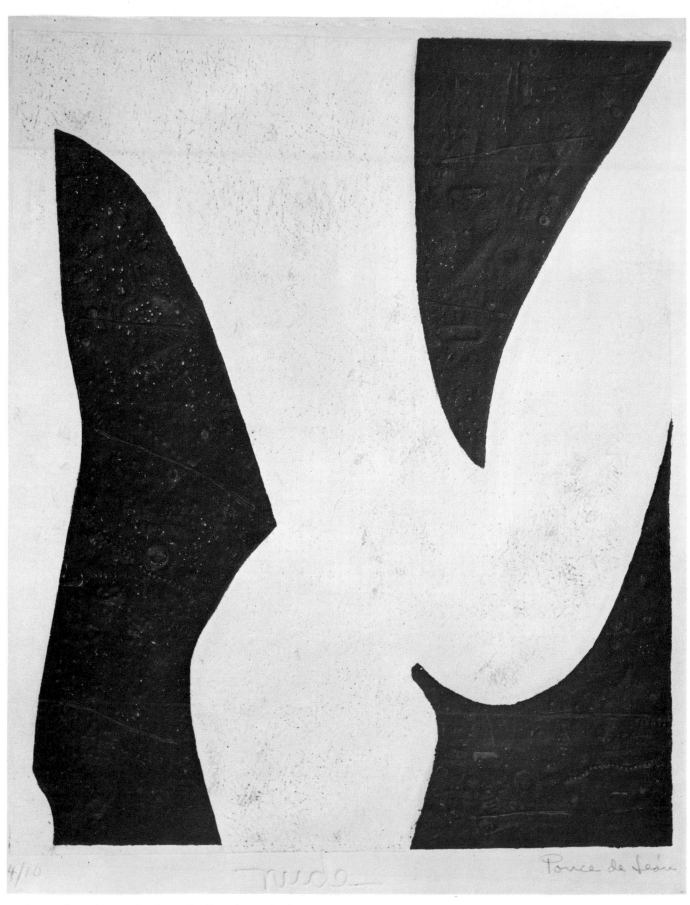

4/10 *Nude* Ponce de Leon

Nude, intaglio etching and embossed collage, by Michael Ponce
de Leon (Achenbach Foundation for Graphic Arts, California
Palace of the Legion of Honor, San Francisco)

Decals are easily available and quite simple to use. First the decal is soaked in water

Then it is transferred to paper

From California . . . A Vigorous Rose, photo-etching and collage by Gordon Thorpe

Decal designs are printed in inks, lacquers, varnishes, or plastics on special paper coated with an adhesive that loosens in water so that the paper, gelatin, or plastic on which the design is printed slides away from the paper backing and can be pasted on the printing surface. Decals can be effectively used with intaglio-printed metal plates. Transfer type, another commercial product, can be placed on the plate or directly on the paper. These plastic letters and numbers come on a sheet of wax paper and can be transferred simply by rubbing with a burnisher. Another commercially printed source for collages or decals is printed materials with gummed backing, such as postage stamps, bumper stickers, and Christmas seals.

To release the ink from a magazine or newspaper picture a solvent such as paint thinner or Naz-Dar clear-base textile ink is used

After the solvent has softened the ink, the image is transferred to paper by burnishing, scraping, or running through the press, and the magazine picture is pulled away

The transfer method is based on the principle of applying an ink solvent to the back of a magazine or newspaper picture to release its ink, which permits the ink to be transferred to a metal plate or a piece of etching paper. Many different solvents can be used successfully: benzine, paint thinner, kerosine, lacquer thinner, Naz-Dar clear-base textile ink, acetone, etc. The etcher softens the ink with the solvent for a few minutes, and then places the picture face down on the plate or on the paper. He transfers the ink by running the plate or the paper through the press, by burnishing, or by scraping with a piece of cardboard until the image has been transferred.

When ink is transferred directly to a metal plate, it acts as an acid resist for a short time. Usually the bitten image is faint and somewhat blurry. Since the ink resist is thin and fragile, it is recommended that the acid be somewhat weaker than what is ordinarily used and that the plate be left in acid for a shorter time. When the image is transferred directly to a piece of etching paper, it is usually overprinted with an intaglio-inked metal plate.

Another transfer process, one that is used exclusively on the paper or printing surface, is a process involving the use of products such as Liquitex polymer medium, transfer gel, and rubber cement. In this method, the ink is in fact transferred to a coat of material painted or sprayed on the paper, rather than transferred directly to the paper itself. With all of these materials the etcher paints two or three coats of the material on both the magazine picture and the printing surface, and when the material has dried for a few minutes, places the magazine picture face down on the prepared area. Then he rubs the back of the picture, or burnishes it, or runs it through the etching press. Usually the magazine picture has to be soaked off the etching paper by placing it in a bath of warm, soapy water. After soaking for a few minutes, the magazine picture can be peeled off or rubbed off, leaving its image on the etching paper.

Because soapy water may be harmful to etching paper, I will describe an alternative transfer method that does not require soaking it. First, the magazine picture and then a piece of clear acetate are painted with one or two even coats of rubber cement. When the rubber cement is thoroughly dry, the magazine picture is placed face down on the acetate and rubbed, scraped, or run through the press, thus transferring the ink to the acetate. The magazine picture is soaked off the acetate. Next, the same steps are repeated, using the image on the acetate and a sheet of etching paper, which is coated with rubber cement only in the area where the image is to be transferred. After rubbing or scraping the acetate to transfer the ink, the acetate sheet is carefully pulled away from the etching paper. Since the rubber cement remains sticky, it is necessary to coat the etching paper with clear spray lacquer or clear plastic before overprinting it with an etching plate.

These transfer methods and others that the printmaker discovers are subject to the many variables involved in commercial inks, printing, and products. Collages, decals, and transfers can often lend interesting color and contrasting imagery to a print.

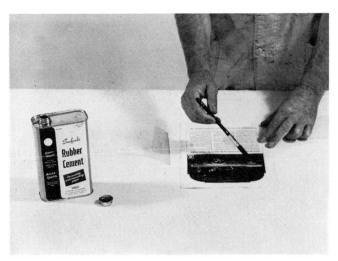

An indirect transfer method involves transferring ink to acetate and then to etching paper from the acetate. First the magazine picture is coated with rubber cement

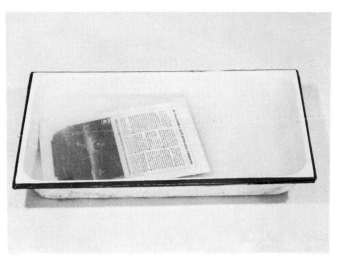

After burnishing, the acetate is separated from the magazine picture by soaking in water

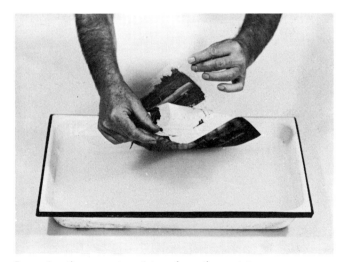

Removing the magazine picture from the acetate

Peeling away the acetate after the magazine picture image has been transferred by burnishing

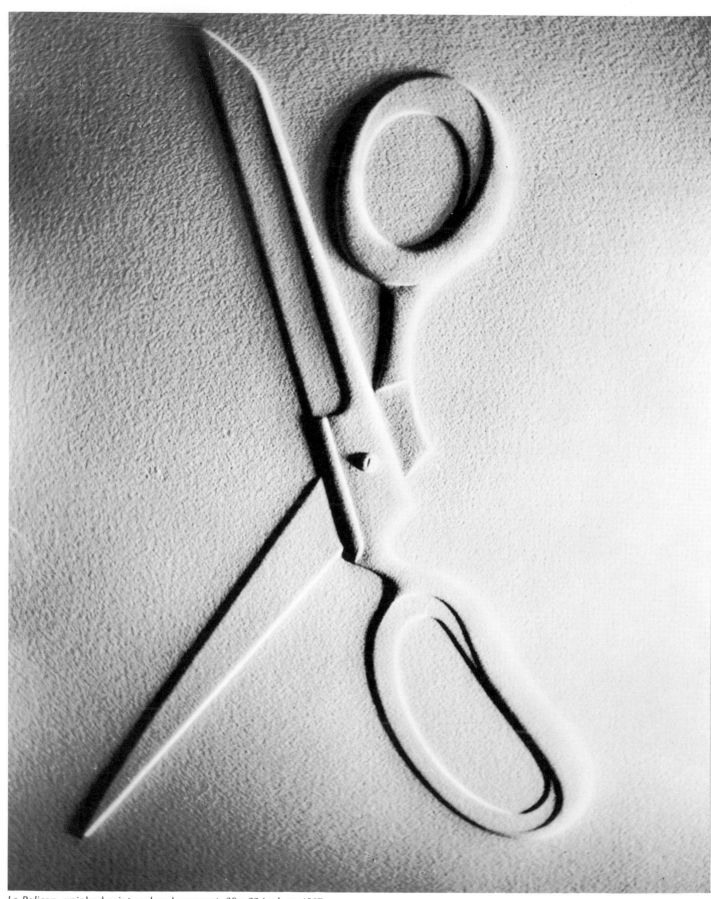

Le Pelican, uninked print and embossment, 30 x 22 inches, 1967,
by Omar Rayo

10. Sculptural Etchings

The sculptural print is a challenge to etchers who wish to explore the interaction between printmaking and sculpture in order to establish a bridge between the relatively two-dimensional world of the etcher and the relatively three-dimensional world of the sculptor. Sculptural etchings can range from deep embossment to etchings in the round. Some etchers want to create sculptural etchings because they feel their designs are more effective when they are three-dimensional.

From the beginning, by the very method the plate is made, inked, and printed, the soft surface of the paper shows at least a slight emboss, and all embossment is relatively sculptural. When transferred to paper, incised lines—engraved or bitten—leave a slight ridge on the paper, made partly because the paper is pushed into the crevices of the metal and partly by the small deposit of ink that is laid along the ridge. When the etcher allows the acid to bite deeper lines and valleys in the metal, then, of course, the damp etching paper is raised even more as it is rolled through the press. If the etcher permits the acid to bite clear through the metal or gouges or drills through the metal, then the embossed areas on the paper will be still more pronounced.

Doublet, intaglio, 17⅞ x 22⅞ inches, by Vredaparis (University Art Museum, University of California, Berkeley)

Life Cycle, etching and embossment by Fotis Korkis

The etching paper can be embossed either by being pushed out as in intaglio printing or in as in relief printing. A plate that has a built-up surface will indent the paper; a plate that has crevices and holes will push out ridges and bumps on the paper. Both kinds of embossment can be combined on a single plate, whether it is made of metal, cardboard, wallboard, Masonite, plywood. All surfaces other than metal should be coated with special glue, brushing lacquer, or shellac to make them moisture proof. The collagraph plate is often very successful as an ink-holding, embossing plate.

Some embossed etchings are designed not to be inked at all. Usually an uninked plate is printed on plain white etching paper in the usual manner, resulting in an embossed etching that uses the play of light and shadow to reveal the image. Low-relief embossing, whether on paper or other materials, is akin to low-relief sculpture. Higher-relief sculpture or additional areas of embossment can be made on an inked or uninked print with a second plate specially constructed out of layers of cardboard or any other suitable material. The etcher takes the impression of the first plate and then redampens the paper and, using pressure from the press or hand pressure, stretches the paper to deeper or higher embossment with a second plate.

An inked etching can be printed and embossed at the same time. When using a two-piece plate (positive and negative mold) intended to print intaglio and to emboss at the same time, usually it is the negative plate that is inked intaglio. The positive mold is prepared with a cushion of felt cloth glued to its surface, which gives the resilient surface that pushes the paper into the holes and crevices of the plate, and transfers the ink from the plate to the paper.

Positive and negative embossing plates. The positive mold (at left) is prepared with a cushion of felt cloth; the negative mold (at right) is usually the one that is inked intaglio

Printing an embossed etching. For high-relief etching, or deep embossment, the pliability of the printing surface is important

The Moon Child/Day and Night, low relief etching by Susan Hules

3-D etching

The limits of embossment are reached at that point where the paper can expand no more without tearing. Therefore, for deep embossment, the thickness, softness, and pliability of the paper or other printing surface is important. Although there are many excellent commercially made etching papers, some etchers have ordered special handmade papers that are extra thick and pliable, giving them an increased capacity for stretching.

Some etchers believe that embossing can be done more effectively on a hydraulic press than on an etching press because of the direct vertical pressure of the hydraulic press. Hydraulic presses suitable for printing etchings are somewhat rare, however, and a few etchers have designed and supervised the building of their own. The advantage is that much thicker materials can be embossed and printed, either inked or uninked. When single embossed plates are printed, first the plate, then the dampened paper, and finally the blankets are laid on top of one another on the press. When two embossing plates are used (a positive and a negative) the paper is slipped between them, and no blankets are used. An ordinary hand-operated letterpress can be used as a substitute for a hydraulic press, provided it is large enough and forceful enough to take a satisfactory impression.

Another kind of sculptural print is the cut-and-folded

Mon, folded intaglio by Shiro Ikegawa

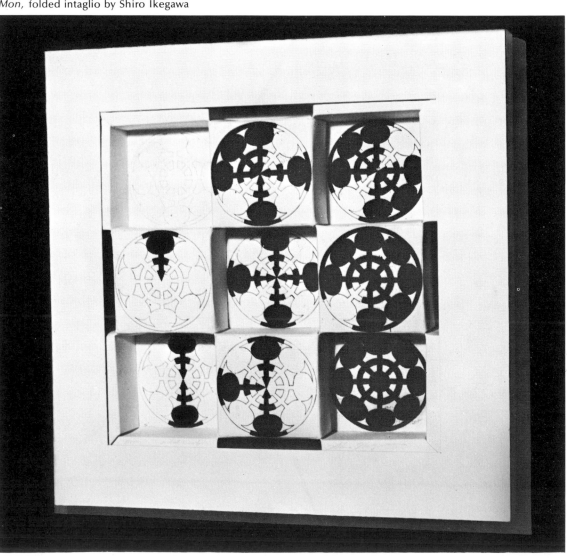

or creased-and-folded print. These can be either high-relief prints or free-standing, sculptural prints. First an impression is taken by inking the plate in the ordinary way and printing it on flat paper or a paper substitute. Then it is cut, creased, folded, glued, or stapled until it has been shaped into a three-dimensional form. Often high-relief prints have to be supported on a cardboard or Masonite backing and made rigid with cardboard or other stiff materials so they will maintain their folded form. When high-relief prints are matted or framed, special demands of protection must be met. Often such prints are framed in deep plexiglass boxes.

When the etcher decides to work in the round, he must first print on a flat surface in the usual way, and then, after the ink is dry, cut and fold the paper or paper substitute into a free-standing three-dimensional shape. The etcher may choose to print on a surface other than paper: aluminum foil, vinyl, plastic, wood veneer, latex, metal. Each of these surfaces has special characteristics in taking an impression and responding to shaping.

These notes on sculptural prints may stimulate some printmakers to explore the potentials of the three-dimensional print. Each individual is encouraged to find materials and to invent techniques that will lead to the production of artistically satisfying prints.

Folding a 3-D etching

Frieze, cut-and-folded etching with stenciled color, 7½ x 18 x 2 inches, by John Opie

Remember Altadena, hand-colored etching, 6 x 9 inches, by John Opie

11. Potentials for Printmaking

People interested in the arts and humanities continue to be fascinated by the art and craft of etching. Some are attracted by the wide range of materials and processes that the etcher can use and others by the opportunity to make editions of multiple-originals. All respond to the special characteristics of line and color that occur when an etching is transferred from plate to paper.

The etcher must remain an artist. To do so he must avoid the temptation to become so involved with techniques that etching becomes merely a craft. He must see beyond his own printmaking speciality and not regard each of the printmaking media as an isolated area of technical development. The artist uses etching as a vehicle for self-expression, and when the limitations of the craft fail to bring the artist to his destination, the craft must be modified, combined with other craft forms, or abandoned. The future usefulness of etching demands that it remain flexible, viable, experimental, and forward-looking in order to meet the artistic needs of contemporary artists in a technically innovative and artistically complex society. The question for etching is not whether it can survive as an ancient and venerable craft of great historical and artistic interest, but whether it can be put to the service of the artist-etcher as a means of self-expression that can meet the needs of contemporary imagery and contemporary attitudes toward media.

Diorama, environmental intaglio by Shiro Ikegawa

Diorama, detail of printed leaf

Hammer, embossed clay print, by John Mason

Fly Matches, intaglio and offset by Corwin Clairmont

In order to become free of the burden of excessive technical complications, the artist-etcher may choose to work in a print workshop in collaboration with a team of experts or a master printer. In the workshop, the etcher is still using hand methods to print a small edition of originals. Conversely, the etcher who turns to the commercial printer for help involves himself in the craft of etching as a supervisor. The work changes from handcraft to machine-craft as he employs photographic equipment and electronic presses of the commercial printer. The edition of prints is large and the distribution widespread; commercial reproduction methods move the print from the domain of the handmade, private, and precious, to the realm of the industrial, public, and low-cost. The commercial engraver's shop may be able to liberate the artist-printmaker from using a handcraft in an automated world.

The non-traditional etcher searches for technical freedom by exploring new processes and combining etching with the non-printmaking media of painting and sculpture.

Color solutions in etching merge into painting; etching in low relief borders on sculpture. Conversely, painters, sculptors, and printmakers will use etching techniques as a support for the resolution of problems in their special arts.

The future of etching lies in its service to artists. To achieve this end, etching must be open and responsive, both technically and artistically, so that the artist can find in it an opportunity for experimentation and individuality. Contemporary etching will be used by artists who do not feel fearful and protective about the long tradition of the etching craft, and instead use it as a tool to meet special needs of self-expression. I propose that the health and vitality of etching as a craft lies in its ability to attract artists working in the mainstream of their time, and that etching must become an "inter-media", interacting with painting and sculpture. The artist must turn to etching as an expression of powers of creation and expression. Etching, painting, and sculpture must be closely linked.

Bibliography

General Printmaking

Brunner, Felix. *Handbook of Graphic Reproduction Processes.* Visual Communications Books. New York: Hastings House, 1962.

Hayter, Stanley W. *About Prints.* Fairlawn, N.J.: Oxford University Press, 1962.

Heller, Jules. *Printmaking Today.* New York: Holt, Rinehart & Winston, 1958.

Peterdi, Gabor. *Printmaking* (rev. ed.). New York: Macmillan Company, 1959.

Sachs, Paul J. *Modern Prints and Drawings.* New York: Alfred A. Knopf, 1954.

Sotriffer, Kristian. *Printmaking, History and Technique.* New York: McGraw-Hill, 1968.

Stubbe, Wolf. *Graphic Arts in the Twentieth Century.* Boston: Boston Book & Art Shop.

Weaver, Peter. *Printmaking: A Medium for Basic Design.* New York: Van Nostrand Reinhold, 1968.

Zigrosser, Carl. *Appeal of Prints.* Greenwich, Conn.: New York Graphic Society, 1970.

Etching and Engraving

Banister, Manly. *Etching and Other Intaglio Techniques.* New York: Sterling Publishing, 1969.

Buckland-Wright, John. *Etching and Engraving: Techniques and the Modern Trend.* New York: Dover Publications.

Gross, Anthony. *Etching and Intaglio Printmaking.* Fairlawn, N.J.: Oxford University Press, 1970.

Hayter, Stanley W. *New Ways of Gravure* (2nd ed.). Fairlawn, N.J.: Oxford University Press, 1962.

Lumsden, E. S. *The Art of Etching.* New York: Dover Publications, 1924.

Middleton, Max J. *Etching and Intaglio Printmaking: A Practical Guide for Beginners.* New York: International Publications Service, 1971.

Block Printing

Banister, Manly. *Prints from Linoblocks and Woodcuts.* New York: Sterling, 1967.

Leighton, Claire. *Wood Engravings and Woodcuts.* Boston: Boston Book & Art Shop.

Sternberg, Harry. *Woodcut.* New York: Grosset & Dunlop.

Tokuriki, Tomikichiro. *Woodblock Print Primer.* San Francisco: Japan Publications.

Lithography

Jones, Stanley. *Lithography for Artists.* Fairlawn, N.J.: Oxford University Press, 1967.

Karch, R. Randolph, and Edward J. Buber. *Graphic Arts Procedures: Offset Processes.* Chicago: American Technical Society.

Knigin, Michael, and Murray Zimiles. *The Technique of Fine Art Lithography.* New York: Van Nostrand Reinhold, 1970.

Poulton, J. *Photolithography, Camera and Platemaking.* Elmsford, N.Y.: Pergamon Press.

Screen Printing

Biegeleisin, J. I. *Screen Printing.* New York: Watson-Guptill, 1971.

Chieffo, Clifford. *Silkscreen as a Fine Art.* New York: Van Nostrand Reinhold, 1967.

Schwalbach, Mathilda V., and James A. Schwalbach. *Screen-Process Printing for the Serigrapher and Textile Designer.* New York: Van Nostrand Reinhold, 1970.

Glossary

adhesive acetate—clear acetate that is sticky on one side. In etching it is used to transfer ink from a magazine picture to a plate

à la poupée—method of color inking in intaglio in which more than one color is inked on a single plate

aquatint—method of producing etched tonal areas by laying on a finely powdered ground, usually rosin

arc lamp—light of high intensity used in photo-plate etching to expose the light-sensitive emulsion

asphaltum—liquid tar used as an ingredient of hard and soft grounds and as a stop-out

assemblegraph—separate plates inked and assembled for printing

autographic ink—greasy ink for black-and-white lithographic work

ball ground—hard ground in the form of a ball

biting—incising metal with acid

bitumen—asphaltum

blanket—band of thick felt used to make a cushion between the roller of the press and the plate and paper

blotter—heavy paper used to absorb moisture of dampened etching paper

brayer—roller used for inking in relief

burin—tool for engraving lines on metal

burnisher—tool used to smooth and polish metal

burr—thin ridge or roughness left by a tool as it cuts into metal

carborundum—powdered abrasive used in graining a lithography stone

cast intaglio—print made with an off-press, gravity-pressure system

collagraph—plate made by gluing material to a plane surface

dabber—soft felt tool used for inking a plate in intaglio

drypoint—process of making intaglio lines by scratching directly into metal, thus raising a burr, or a print produced by this method

Dutch mordant—etching mixture of hydrochloric acid, potassium chlorate and water

edition—entire number of prints taken from a plate. The edition and the number of the particular print in the edition are usually shown on the margin of the print

embossing—raising portions of a surface into relief

engraving—process of making intaglio lines by incising metal with a burin, or print produced by this method

etching—process of making intaglio lines and tonal areas by the action of acid on metal, or print produced by this method

felt—blanket used on an etching press

ferric chloride—etching mordant also called perchloride of iron

film stencil—laminated stencil composed of lacquer film and backing

gouges—"V" shaped and "U" shaped blades used to cut into pregnable surfaces

grain—in lithography, producing a tooth on the surface of a stone with carborundum

gum arabic—tree-gum glue used in preparing a lithography stone

halftone—photoengraved image producing tonal gradation by different distributions of dark dots

halftone screen—film containing a dot pattern used in producing halftones

hard ground—acid-resistant asphaltum ground that comes in ball or liquid form

impression—printed image taken from a plate

intaglio inking—method of inking that leaves ink in low (incised or bitten) places of the plate

levigator—metal disc used to grain a lithographic stone

lift ground—ground that dissolves in water (usually a sugar solution) and produces brush-stroke textures on the plate

mezzotint—process of producing a mechanical burr on a metal plate by using a mezzotint rocker, or the print produced by this method

mordant—acid solution used for etching a metal plate

offset printing—any method of indirectly transferring ink from one surface to another through an intermediate transfer of the ink to a roller

open-plate bite—process of etching sections of a plate in acid without first coating with ground

papier mache—paper pulp molded with water and some adhesive. It is used in commercial printing as the mold in which a positive lead plate is poured

photo-plate—metal plate, coated with a light-sensitive emulsion, that can be exposed and developed to show an image

photo-stencil—photosensitive gelatin tissue used in the screen-printing process

plate—surface from which prints are taken

plate mark—uninked, embossed mark left on the printing paper by the borders of the plate

proof—trial impression, or print

registration—correct placement of an image (on printing surface or plate) in relation to a previously printed image

relief inking—applying ink, usually with a roller, to the raised surfaces of a plate or block

rocker—tool used to roughen the surface of a metal plate in mezzotint printing

roller—rubber or gelatin brayer

rolling up—establishing a visible image on a lithographic stone by rolling ink over the stone with a leather roller

rosin—natural, acid-resistant resin used in aquatints

sand-grain aquatint—process of producing a tonal surface on a plate by laying sandpaper on it and running both through the etching press, or print produced this way

scraper—tool used to erase lines on a metal plate by removing metal

shore—measurement, in degrees, for the relative hardness of gelatin rollers

soft ground—acid-resistant ground consisting of a mixture of beeswax and liquid asphaltum

spit-biting—etching technique in which saliva is used to confine acid to a limited area

spray-ground aquatint—porous ground applied from a pressurized can of lacquer or varnish

squeegee—rubber blade (in holder) or piece of cardboard used mainly in silk-screen printing to distribute and apply ink through a screen

state—stage of development of a print (usually one that is complete enough to print an edition)

stereotype plate—commercial cast plate made from a papier mache mold and used for printing in newspapers or magazines

stop-out—acid-resistant substance used to protect portions of the plate after the initial ground has been applied. Stop-outs are made of asphaltum, varnish, or shellac

stopping out—protecting a plate by painting it with acid-resistant materials

sugar aquatint—process of creating tonal areas on a plate by sprinkling sugar into a wet hard ground

sugar lift—lift-ground method of aquatinting in which the plate is sprinkled with darkened grains of sugar

tarlatan—thin, stiff muslin used for wiping inked plates

transfer printing—process of using a previously printed or drawn design to produce an image on a stone or plate

transparency—photo-negative or -positive used in photo-plate etching

tusche—greasy substance, in liquid or crayon form, used in drawing on lithographic stones and as a resist on screen stencils

tympan—smooth flat sheet under the scraper bar of a lithographic press. In printing it is well greased to reduce friction

vacuum-form machine—combination of a vacuum chamber and a heating element that molds plastic into a vacuum-form print. It can be used to make both plates and prints

vacuum frame—device for holding a photo-plate in position with vacuum pressure as it is being exposed to an arc lamp

viscosity—ease of flow of a liquid

viscosity printing—method of color printing based on the relative oiliness or stiffness of pigments

wet on dry—term used to describe overprinting one color on another after the first has been allowed to dry

wet on wet—term used to describe overprinting one color on another while the first is still wet

wiping—part of the intaglio-inking technique in which the high placed parts of a plate are cleaned so that ink remains only in the incised lines

Index